IMAGES
of America

THE FINANCIAL DISTRICT'S
LOST NEIGHBORHOOD
1900–1970

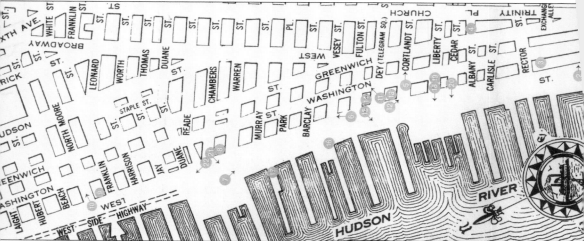

This 1930s map shows the tip of Lower Manhattan and the streets that bordered the Financial District's lost neighborhood. The neighborhood's tenement buildings were tightly nestled among the tall skyscrapers of the Lower Battery. The neighborhood began at Battery Place to the south (across from Battery Park) and was bounded by West Street (now the West Side Highway) to the west; it continued north to Liberty Street (where the World Trade Center once stood) and stretched as far as Broadway to the east. In the 1940s, a large percentage of the neighborhood's residential buildings south of Edgar Street were demolished to make way for the Brooklyn Battery Tunnel.

IMAGES
of America

THE FINANCIAL DISTRICT'S
LOST NEIGHBORHOOD
1900–1970

Barbara and Martin Rizek
and Joanne Medvecky

ARCADIA

Published by Arcadia Publishing
Charleston SC, Chicago IL, Portsmouth NH, San Francisco CA

Printed in Great Britain

Library of Congress Catalog Card Number: 2003115628

For all general information contact Arcadia Publishing at:
Telephone 843-853-2070
Fax 843-853-0044
E-mail sales@arcadiapublishing.com
For customer service and orders:
Toll-Free 1-888-313-2665

Visit us on the internet at http://www.arcadiapublishing.com

CONTENTS

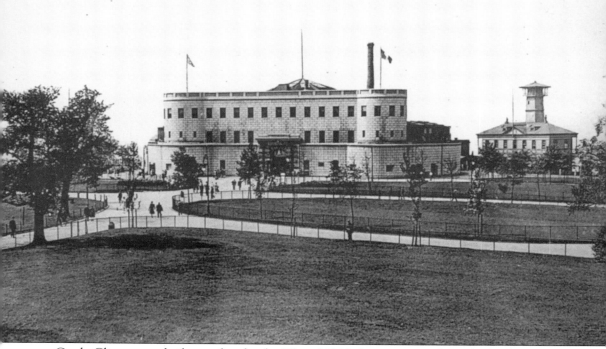

Battery Place - Aquarium
New-York City

Castle Clinton was built as a fort for the War of 1812. It was renamed Castle Garden after it was remodeled as a concert hall in the mid-1800s. This 1930s photograph was taken when the building was being used as an aquarium. It remained as such until 1941, when the aquarium was moved to Coney Island, Brooklyn. The building was destined for demolition in the 1940s to make way for the proposed Harbor Bridge that was to connect Manhattan to Brooklyn. This later became the Brooklyn Battery Tunnel. Since then, the building has had multiple uses. Today, it houses ticket booths for the ferry to Ellis Island and the Statue of Liberty. (Courtesy of Martin and Barbara Rizek.)

INTRODUCTION

Each day, thousands of motorists travel back and forth through the Brooklyn Battery Tunnel—the conduit that links Lower Manhattan to the borough of Brooklyn. The entrance and exit ramps wind in and out of the tunnel through a small section of New York City's Financial District. When the tunnel and the ramps were built in the 1940s, it became necessary to destroy what was there before.

What was there before was a neighborhood. Due to the failure to construct a bridge connecting Brooklyn to Manhattan, city planner Robert Moses decided to build a tunnel instead. To do so, many families had to be uprooted and buildings demolished through eminent domain. Within a matter of several years, a major portion of a once thriving and close-knit neighborhood was destroyed to make way for the Brooklyn Battery Tunnel.

Little has been written about this neighborhood—the "lost" neighborhood of New York's Financial District. One-time residents affectionately refer to it as Downtown and to themselves as Downtowners.

In the mid- to late 19th century, many immigrants who arrived at Ellis Island from Czechoslovakia, Poland, Greece, Ireland, Lebanon, and Syria decided to take a short trip from the island to the Battery in Lower Manhattan. They settled where they first stepped foot, moved into the tenement buildings surrounded by skyscrapers, and remained in Downtown for close to a century.

Unlike many residents of tenement neighborhoods, these people did not want to leave the place they called their "village." Although the apartments were small, the bathrooms were in the halls (and sometimes in the yard), the bathtubs were in the kitchen, and coal stoves were used to heat the apartments, they enjoyed their life in Lower Manhattan. These settlers made certain that the neighborhood was always safe and clean. The apartments and buildings were always immaculate.

One of the main streets of the neighborhood was Greenwich Street. Once considered Manhattan's early Park Avenue, Greenwich Street was home to merchant princes and wealthy ship owners during the early 1800s. The street was lined with mansions belonging to such notable families as the Roosevelts, Schermerhorns, Aspinwalls, Delafields, and Beekmans. By 1840, most of the original homeowners left Greenwich Street and settled farther uptown. The city was growing fast, and the tenements soon replaced the homes of the affluent.

The area was ethnically diverse. The Irish were one of the early settlement groups who inhabited the neighborhood. While many of them eventually left the area, a number of families

remained, continuing to work on the piers along West Street and actively participating in local First Ward politics.

In the late 19th century, the neighborhood was home to a large percentage of Syrian and Lebanese immigrants. Downtown became known as "Little Syria," and Washington Street was where many of them lived and where they maintained their businesses: lingerie, import and export shops, and restaurants. The first Lebanese Maronite Christian mission in the United States was founded on Washington Street.

The neighborhood was also home to a large percentage of the city's Slovak and Carpatho-Rusyn immigrants who came from eastern Europe at the beginning of the 20th century. They too lived, worked, and owned businesses in Downtown.

Public School 29, on Washington and Albany Streets, is where the majority of the children in the neighborhood went to school. Another school was St. Peter's School, affiliated with St. Peter's Roman Catholic Church, on Barclay Street, which was open from 1840 to 1940. It closed because of a decline in the number of residents living in Downtown after the construction of the Brooklyn Battery Tunnel. At one time, the school had 1,800 students. When it closed, it had 60. Unlike St. Peter's, Public School 29 kept its doors open until 1960—teaching the last children in the neighborhood.

Several places of worship were located in the neighborhood and had an impact on the immigrant community. In addition to St. Joseph's Maronite Church, which served the Syrian community, St. Nicholas Greek Orthodox Church, on Cedar Street, served Downtown's Greek immigrants. It remained an active church for decades. Many of its members, long gone from the neighborhood, traveled into Lower Manhattan to attend services there until the church building was destroyed on September 11, 2001.

St. Peter's Church, the oldest Roman Catholic Church in New York, attended to the Roman Catholic residents of Downtown. The church provided games and recreation for the children of the neighborhood. The Legion of Mary took the children of the area to the circus and rodeo, on picnics, and to ball games at Yankee Stadium.

Trinity Episcopal Church, on lower Broadway, played an important role in the neighborhood as well. The church reached out to the community in a number of ways, particularly through its Mission House, located at 211 Fulton Street. The mission opened its doors in 1876 and closed them in 1955. The Mission House had a dispensary under the supervision of a physician and Sunday school classes. It was a place where lectures, dances, parties, and shows took place. The Mission House also provided a summer camp for the neighborhood children.

St. Stephen's Guild was a popular organization for the young adults of Downtown. Martin Rizek was president of the guild from 1958 to 1996. He and his wife, Barbara, ran annual Downtown reunion dances for 30 years. The first few were run by John Hornak, Dave Srour, and Timothy Buckely. At the last reunion in 1996, some 290 former Downtowners attended. Many came from as far away as California, as well as Maine, Florida, West Virginia, and New Jersey.

One

NEIGHBORHOOD LIFE

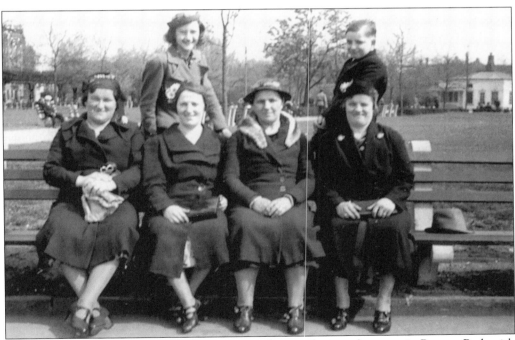

Downtowners in their Sunday clothing are spending a relaxing afternoon in Battery Park with their friends and family in May 1940. Many residents who worked six days a week enjoyed going to Battery Park during the warm-weather months. (Courtesy of Mary Medvecky.)

Emily Mica (left) and Anna Slezak are pictured here under the Ninth Avenue El at 64 Greenwich Street in 1937. (Courtesy of Joan O'Connor.)

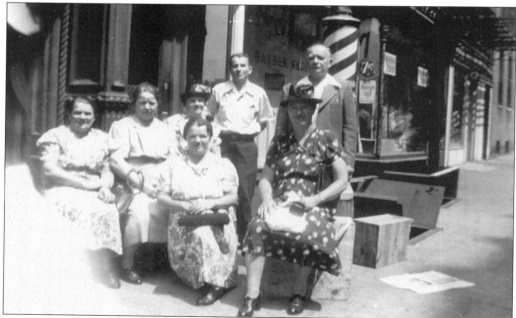

On typical Saturday afternoons, friends and family would gather outside their neighborhood residences. In this 1947 photograph, the Yanoscik and Derevjanik families are shown outside of their home at 9 Albany Street. (Courtesy of Mary Medvecky.)

Neighborhood boys stand on the corner of Edgar and Greenwich Streets. They are Paul Karpiscak, Paul Chrenka, Martin Rizek, and John Kormanik. A graduate of Purdue University, Paul Karpiscak was the Martin Company's senior rocket propulsion engineer responsible for operating the firing console for launching Vanguard rockets and satellites into space. (Courtesy of Martin and Barbara Rizek.)

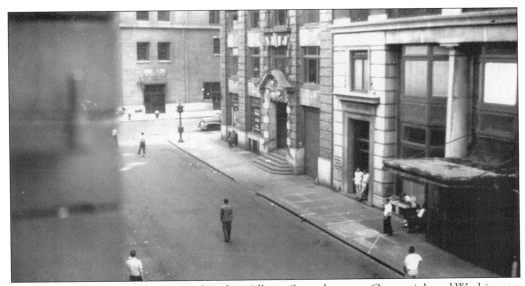

Every Sunday, a stickball game was played on Albany Street between Greenwich and Washington Streets. The players established teams, each team represented by the streets where the players lived. This photograph was taken in 1946. (Courtesy of John and Helen Fornazor.)

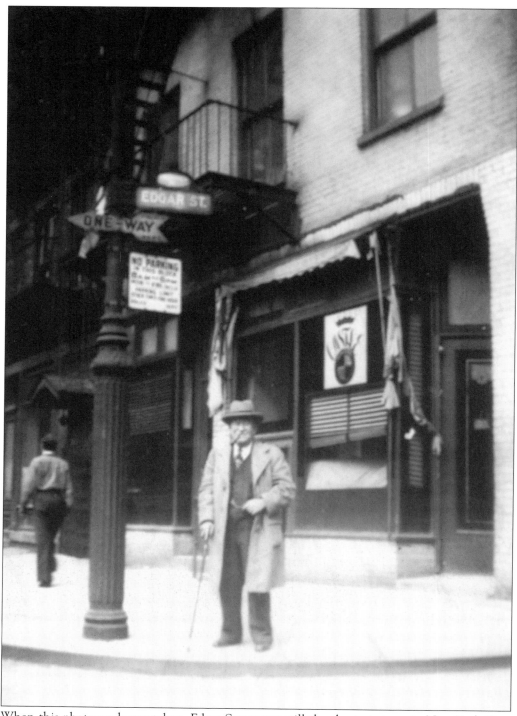

When this photograph was taken, Edgar Street was still the shortest street in New York City. Originally 57 feet long, the street was lengthened in the 1940s to accommodate the entrance to the Brooklyn Battery Tunnel. (Courtesy of John Taaffe.)

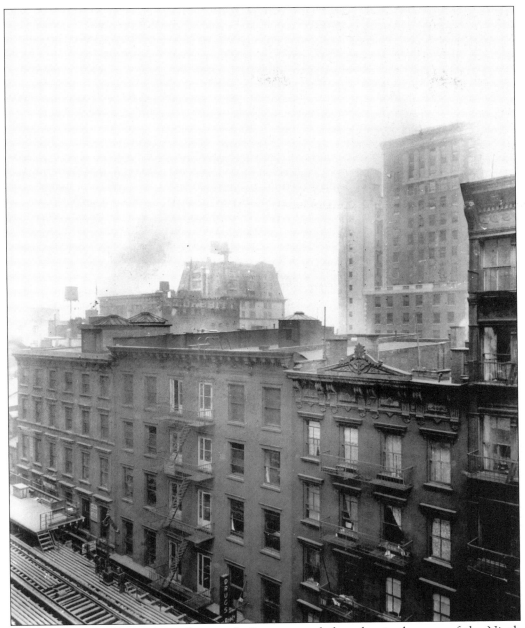

The tenement buildings along Greenwich Street were dark and noisy because of the Ninth Avenue El, which ran along Greenwich Street. While sitting on the fire escape, one could almost touch the train tracks. When the el was torn down, sunshine shone in the apartments. The building at 106 Greenwich Street is still standing, and its apartments continue to be occupied by tenants. (Collection of the Museum of the City of New York.)

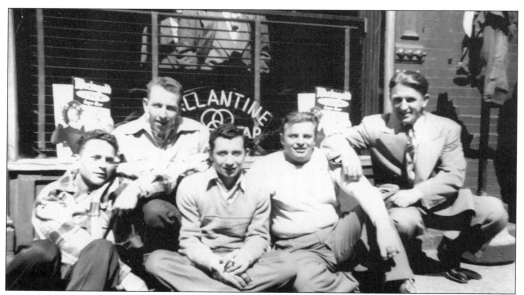

Stickball players are resting in front of Martin's Bar and Grill (on Albany Street), a popular place to go after a game. From left to right are John "Lindy" Kormanik, Donald "Red" Summerville, Alex "Roosh" Rusinak, John "Derro" Derevjanik, and Andy "Shorty" Stack.

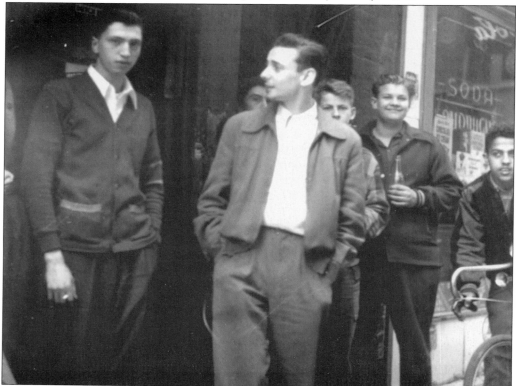

The neighborhood boys in front of George's Candy Store, on Albany Street, are making plans for a stickball game. (Courtesy of John and Helen Fornazor.)

14

Gil and "Snuffy" Norton are quenching their thirst on the corner of Albany Street on July 25, 1936. The Nortons lived on Washington Street. (Courtesy of Mary Medvecky.)

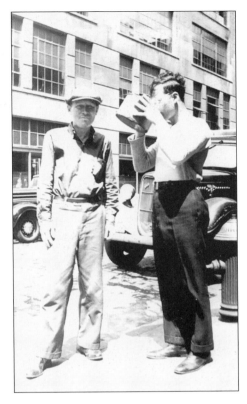

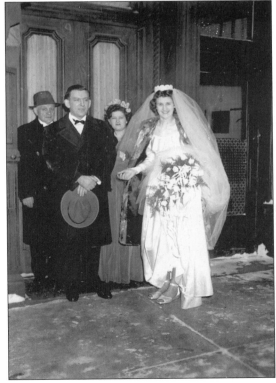

Anna Yanoscik Kozar is pictured at the entrance of 9 Albany Street, leaving for her wedding ceremony at St. Nicholas Carpatho-Russian Orthodox Church (on the Lower East Side) during one of New York's worst snowstorms, in January 1948. (Courtesy of Mary Medvecky.)

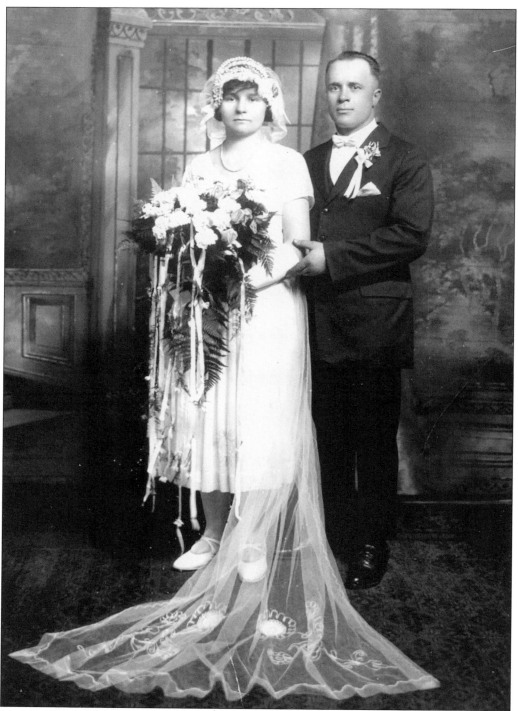

This is the wedding portrait of Anna and John Mica. The Micas owned and operated a restaurant at 149 Washington Street. John Mica was a veteran of World War I. He arrived in this country from Slovakia in 1913 at the age of 17.

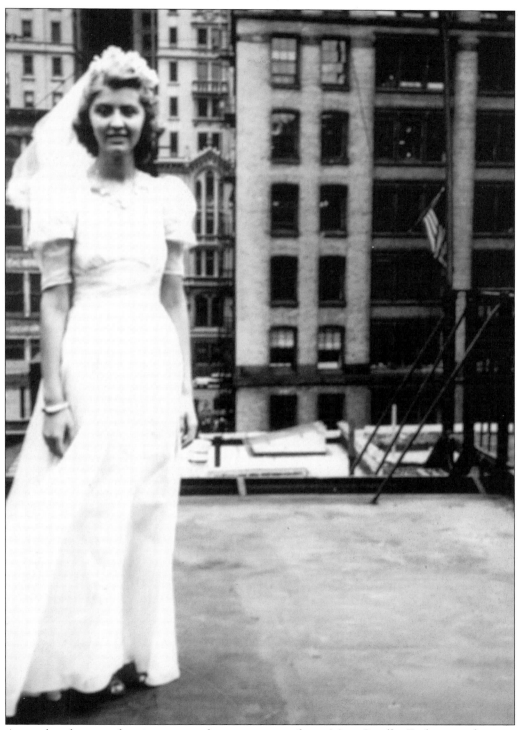

A popular place to take pictures was the tenement rooftops. Mary Ceselka Zizik is seen here on a rooftop on Albany Street. (Courtesy of Frank and Mary Zizik.)

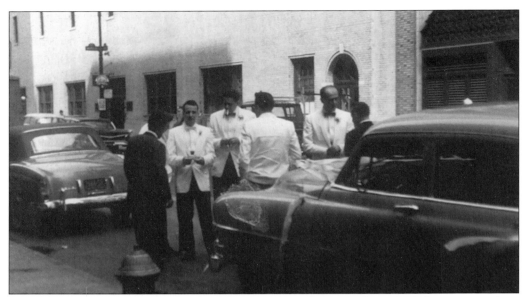

A wedding party congregates outside of the groom's residence on Greenwich Street across from the back entrance of the American Stock Exchange in 1960. The wedding ceremony took place at Holy Trinity Lutheran Church. (Courtesy of Martin Rizek.)

Ushers wait for groom-to-be John Fornazor to come down from his apartment on Albany Street in May 1951. He and his bride, Helen Ceselka, were married at St. Nicholas Carpatho-Russian Orthodox Church, on East 10th Street and Avenue A. (Courtesy of John and Helen Fornazor.)

Stefan and Anna Podzamsky, residents of 63 Greenwich Street, are enjoying a Sunday dinner in their kitchen in 1939. Most tenement apartments had two to three rooms with a bathtub in the kitchen and a toilet in the hallway that was shared by other building residents. (Courtesy of John Taaffe.)

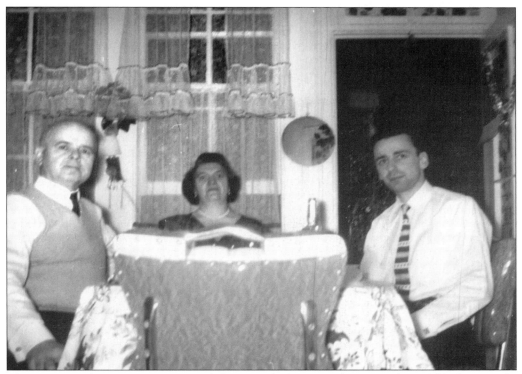

The interior of an apartment at 106 Greenwich Street is shown in this 1957 photograph. (Courtesy of Martin and Barbara Rizek.)

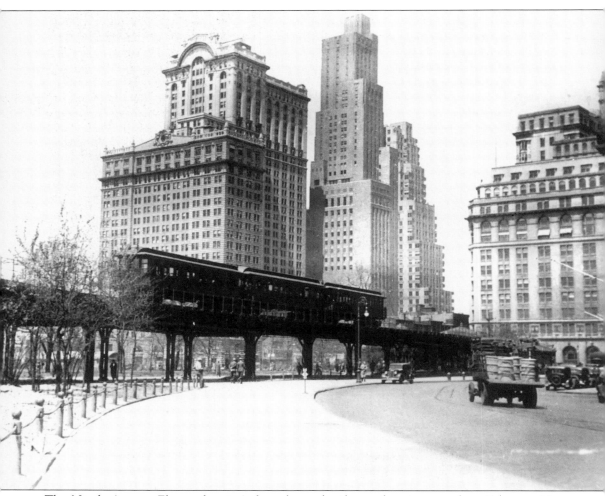

The Ninth Avenue El was the city's first elevated railway when it opened on February 14, 1870. The line ran along Greenwich Street and Ninth Avenue. It was the main mode of transportation for Downtown residents. The building in the background is the Whitehall Building, at 17 Battery Place and West Street. The Renaissance structure with its limestone facade became New York City's largest office tower, at the time, when a 31-story addition was completed in 1910. (Collection of the New-York Historical Society.)

In 1941, Joan Praskać is shown here standing under the Ninth Avenue El in front of Greenwich Street. (Courtesy of Joan O'Connor.)

Elizabeth Slezak and a friend are standing under the Ninth Avenue El at 68 Greenwich Street in 1936. (Courtesy of Joan O'Connor.)

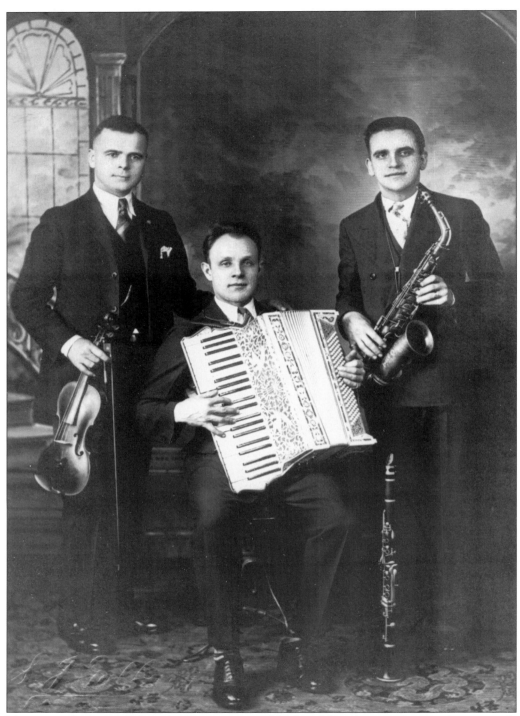

Music was a big part of life in the Downtown neighborhood. Residents were not rich monetarily but rich in culture. Almost every weekend, these musicians played at a dance, wedding, or picnic. (Courtesy of Martin Rizek.)

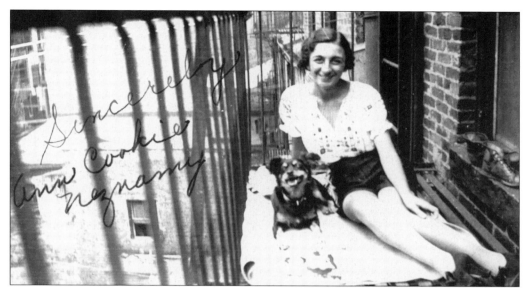

Anna Neznamy is on the fire escape at 64 Greenwich Street in July 1937. Tenants sat on fire escapes when their apartments became too warm during the summer months. (Courtesy of Elizabeth Sukupcak.)

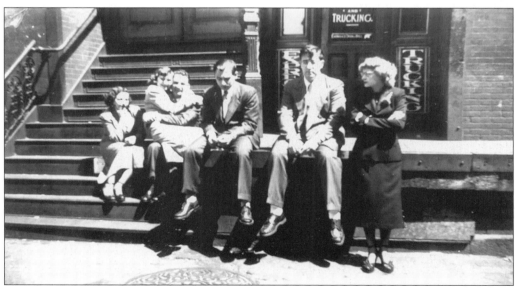

The steps of the Pandick Press building, at Albany and Greenwich, were a popular place to sit. This photograph was taken on a Sunday afternoon in 1954.

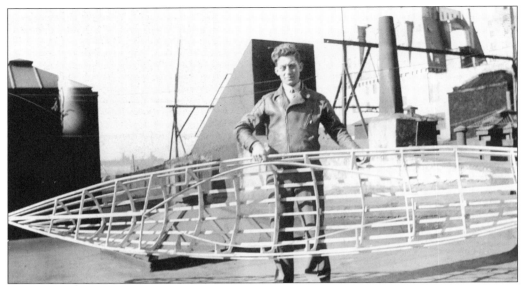

William Klus, an aspiring engineer and resident of 51 Washington Street, is shown constructing a canoe in this 1937 photograph. Building the canoe was easy, but getting it off the roof was difficult. The solution was to tie it securely and slowly lower it down the side of the building with the help of other building residents. (Courtesy of Martin and Barbara Rizek.)

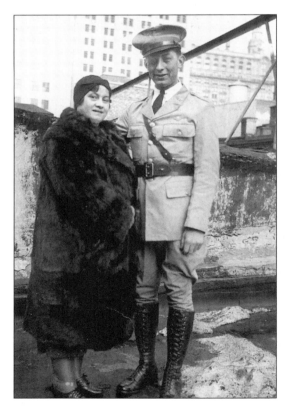

On the rooftop of 51 Washington Street in 1937 are Anna Klus and her son William, a Merchant Marine Academy student. In the background are some of the buildings on West Street.

Most family pictures were taken on the roofs of the tenement buildings. The open space, bright lighting, and interesting backdrop of Manhattan resulted in memorable snapshots. This photograph was taken on the roof of 18 Trinity Place. Mrs. Vislocky is shown standing with her friends; each is elegantly dressed in a fur-trimmed coat. (Courtesy of Michael Vislocky.)

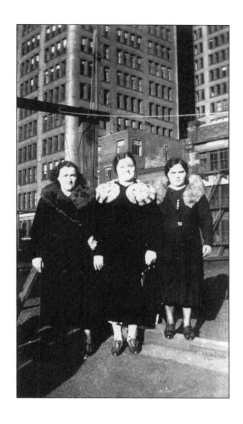

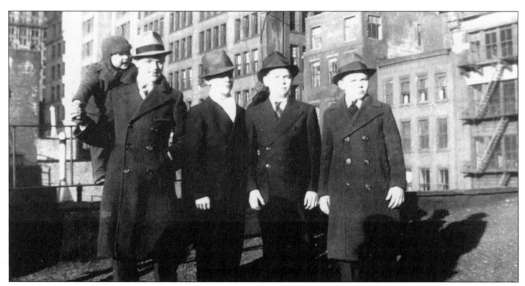

Michael and Charles Vislocky and friends are shown dressed in their Sunday suits and hats. (Courtesy of Michael Vislocky.)

This photograph of three-year-old Anna Slezak was taken in 1918 on the rooftop of a building on Washington Street. Note the pocketbook at her feet. (Courtesy of Anna Praskać.)

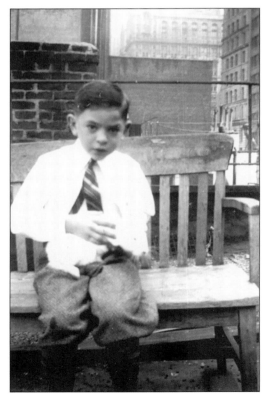

Michael Vislocky is shown here as a young boy holding his pet rabbit on the rooftop of 18 Trinity Place in 1940. (Courtesy of Michael Vislocky.)

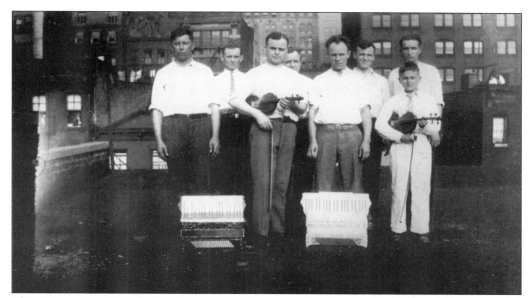

This Downtown Slovak band was a popular musical group that performed for the Lower Manhattan Slovak community. The group poses before a practice session and a performance on the roof of 66 Greenwich Street in 1928. The members are, from left to right, as follows: (first row) John Kalka, Martin Rizek Sr., Paul Slezak, and John Slezak Jr; (second row) Paul Rizek, John Krasikar, John Slezak Sr., and John Jozefek. (Courtesy of Martin and Barbara Rizek.)

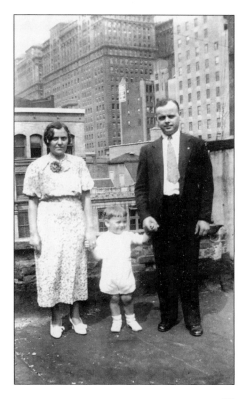

Bandleader Martin Rizek Sr. is on the roof at 65 Greenwich Street with his wife, Susan, and son Martin Jr. in 1935. In the background are the skyscrapers of lower Broadway.

This 1944 photograph shows two area residents standing in Bowling Green Park, which was a popular spot for picture taking at the foot of Broadway. This historical location was a parade ground and marketplace during the late 1600s. It was designated New York City's first official park in 1733 by a resolution of the Common Council. The building behind these two sisters, Mary and Anna Yanoscik, is the Standard Oil Company Building, at 26 Broadway, built in 1922 as the headquarters of Standard Oil. (Courtesy of Mary Medvecky.)

While on leave from the U.S. Army, 2d Lt. George Noga, a resident of 46 Washington Street, is standing in City Hall Park. After Noga's discharge, he played third base for the Chicago White Sox farm team and later became coach for the same organization. (Courtesy of Michael Vislocky.)

Area residents often used the yard of Trinity Church as a shortcut from the west side to the east side of Broadway. In the background of this 1945 photograph is the New York Curb Exchange building, which now houses the American Stock Exchange, at Trinity Place and Rector Street. (Courtesy of Mary Medvecky.)

Mary Ceselka and her future husband, navy man Frank Zizik, are shown standing in the yard of Trinity Church. (Courtesy of Frank and Mary Zizik.)

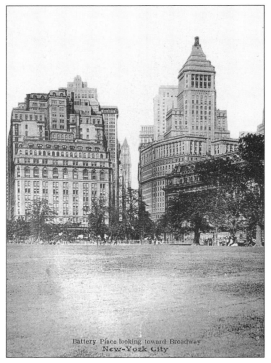

Battery Place looking toward Broadway
New-York City

Battery Park, shown in this postcard, is located on the southern tip of Manhattan. Throughout its history, the park has been a favorite gathering place for people wishing to sit and admire its spectacular harbor views. Named after the battery of cannons that occupied this open area during the late 1600s, Battery Park was an oasis for Downtown residents who did not have backyards of their own. (Courtesy of Martin and Barbara Rizek.)

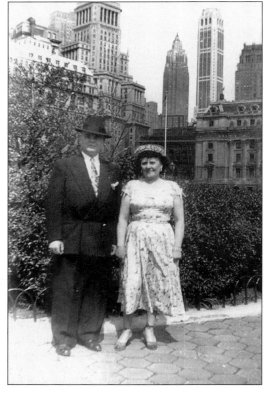

Downtown residents are shown posing in Battery Park in this 1953 photograph. In the background to the right is the U.S. Customs House. The U.S. Customs House, at 1 Bowling Green between State Street and Whitehall Street, was built in 1907. This magnificent Beaux-Arts granite building housed the Custom Service until 1973, when it moved to the World Trade Center. The building remained vacant until 1994, when it became the home of the National Museum of the American Indian.

First-time father Nicholas Bulko, who lived on Washington Street, holds his daughter Lillian in Battery Park with Castle Clinton in the background in 1942. (Courtesy of Mary Medvecky.)

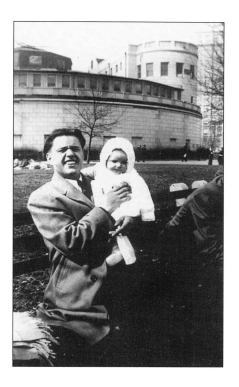

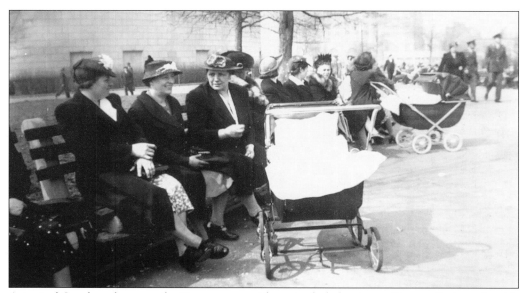

A typical Sunday afternoon for Downtown residents included going to Battery Park to sit with family and friends. Some people arranged the park benches by the village or community they came from. Here families with children and baby carriages are seated in Battery Park in 1942.

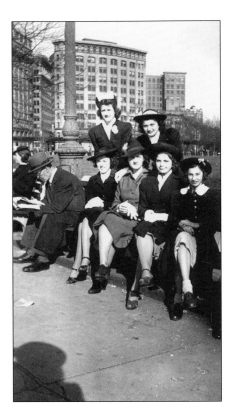

Young women socialize on a park bench in Battery Park in 1940. In the background, the Ninth Avenue El stretches along the eastern edge of the park. (Courtesy of Mary Medvecky.)

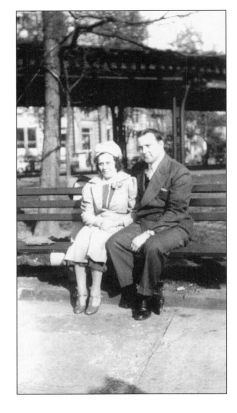

The noisy Ninth Avenue El heads for its last stop downtown. Two area residents are shown here on a park bench in Battery Park in 1934. The train can be seen passing by, above their heads. (Courtesy of Anna Praskać.)

A young girl is shown sitting on a bench in 1942 in Battery Park. In the background are the skyscrapers on State Street, just south of the park.

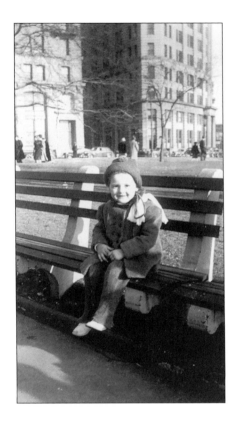

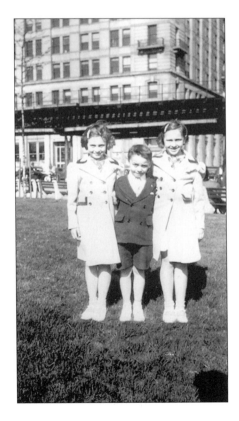

Downtown children are pictured in Battery Park on a Sunday afternoon in 1940. The Ninth Avenue El is in the background, running along State Street.

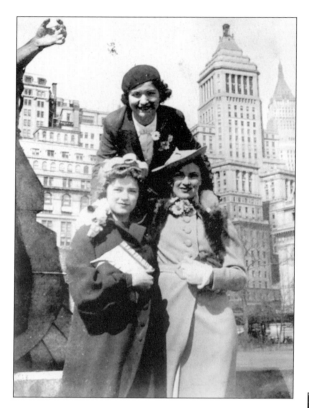

Neighborhood girls happily pose in Battery Park in 1938. The hand jutting out in the upper left corner of the photograph belongs to the statue of Amerigo Vespucci, the famous Italian explorer. The statue is no longer in the park. From left to right are Katherine Taaffe, Muriel Summerville, and Mildred Mascara. (Courtesy of John and Katherine Taaffe.)

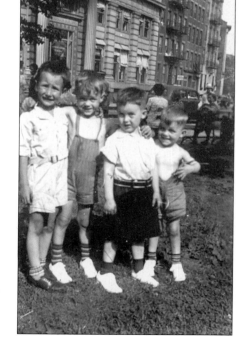

On a Sunday afternoon in 1950, a favorite spot for Downtowners was Battery Park. In the background is the old post office building and the skyscrapers of Wall Street. From left to right are Jimmy Taaffe, John Taaffe, Eddie Taaffe, and Pat Taaffe.

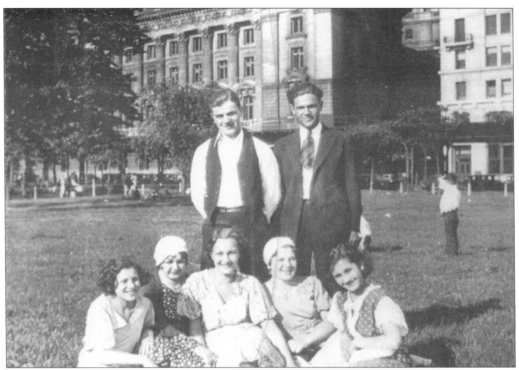

This photograph shows a group of friends in Battery Park in the summer of 1933. (Courtesy of John Taaffe.)

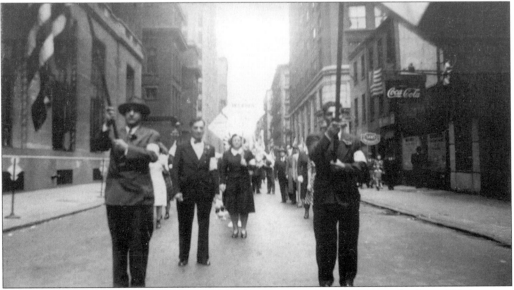

In 1944, during World War II, the neighborhood air wardens led a parade down Washington Street. In the background on the left are the New York Post building and Public School 29. The marchers include Joseph Sahadi (center). The Sahadi family ran an import-export business on Washington Street. (Courtesy of Marian Sahadi Ciaccia.)

Michael Yanoscik (right) was the first soldier from Downtown to die during World War II. He is pictured here with his brother Joseph Kindya on the roof at 9 Albany Street. (Courtesy of Mary Medvecky.)

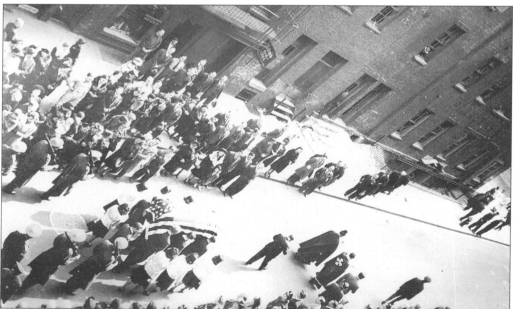

Neighbors line Albany Street as the funeral procession passes and makes it way to St. Nicholas Carpatho-Russian Orthodox Church, on the Lower East Side, for the funeral services. (Courtesy of Mary Medvecky.)

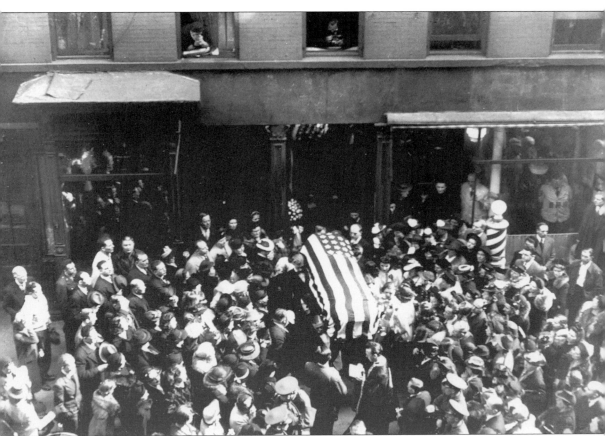

Before a funeral, deceased family members were often laid out in their homes. Shown here is a view of the casket being removed from Michael Yanoscik's residence at 9 Albany Street in 1942. A large gathering of Downtown residents surrounds the entranceway to pay tribute. (Courtesy of Mary Medvecky.)

On May 14, 1942, the Downtown neighborhood organized a parade in honor of the soldiers from the First Ward. The parade was given in memory of Michael Yanoscik, who was the first soldier from the neighborhood to die in World War II. Neighbors are standing on steps in the background. (Courtesy of Mary Medvecky.)

This large banner was draped across Washington Street. It contained a star for each soldier serving overseas. The center star was placed in honor of Michael Yanoscik. (Courtesy of Mary Medvecky.)

This view of the parade looks south on Washington Street as the marchers pause in front of St. Joseph's Maronite Church. The 1942 parade shows how close-knit the community was and how well the various ethnic groups lived and worked together. Neighborhood friends Azeez Najar (a Lebanese dockworker), James Cox (an Irish policeman), and Joseph Radnov (a Polish tavern keeper) organized the parade in honor of Michael Yanoscik, who was of Carpatho-Rusyn descent. (Courtesy of Mary Medvecky.)

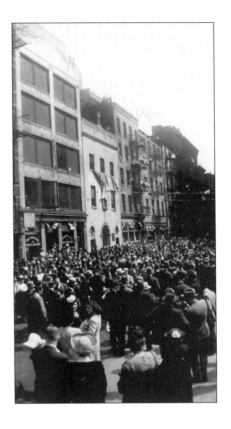

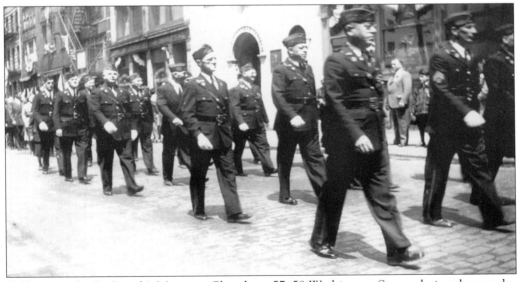

Soldiers pass by St. Joseph's Maronite Church, at 57–59 Washington Street, during the parade.

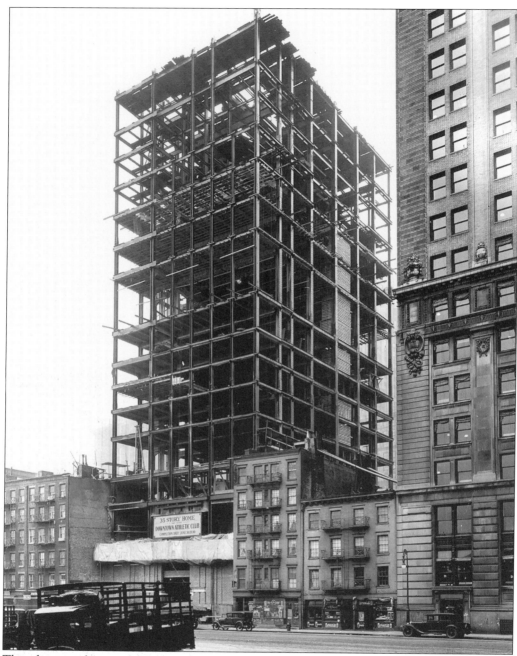

This photograph was taken in 1929 during the construction of the Downtown Athletic Club, a private men's club located at 19 West Street. The 38-story Art Deco skyscraper, completed in 1930, boasted a gymnasium, a swimming pool, squash and tennis courts, and a miniature golf course, as well as a dining room and living quarters. Its members worked for the law offices, banks, and shipping companies located downtown. The building is best known as the home of the Heisman Trophy. To the left and the right of the building are tenement buildings that were later torn down to build other office towers. (Courtesy of John Taaffe.)

Two

STORES

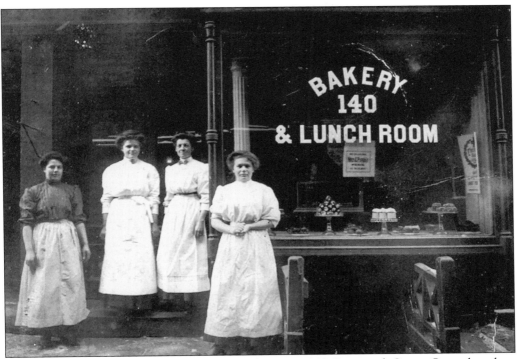

This 1917 photograph shows a bakery and lunchroom at 140 Greenwich Street. Several workers pose before going back into the restaurant to finish their day's work. (Courtesy of John Taaffe.)

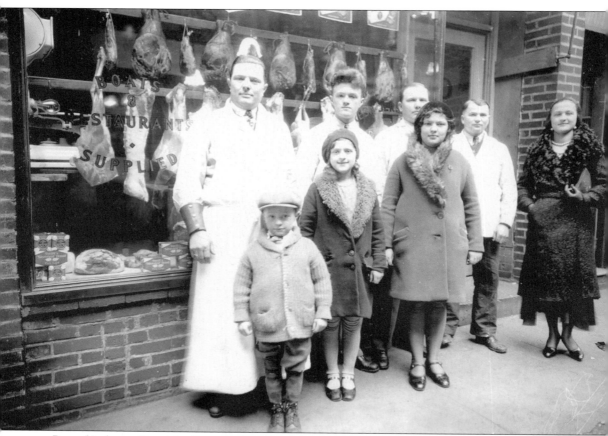

Peter Herko, a Carpatho-Rusyn immigrant, and his family are pictured in front of their meat store. The shop sold to banks, brokerage houses, law offices, and shipping companies located around Wall Street. Downtown residents also shopped there. (Courtesy of Mary Medvecky.)

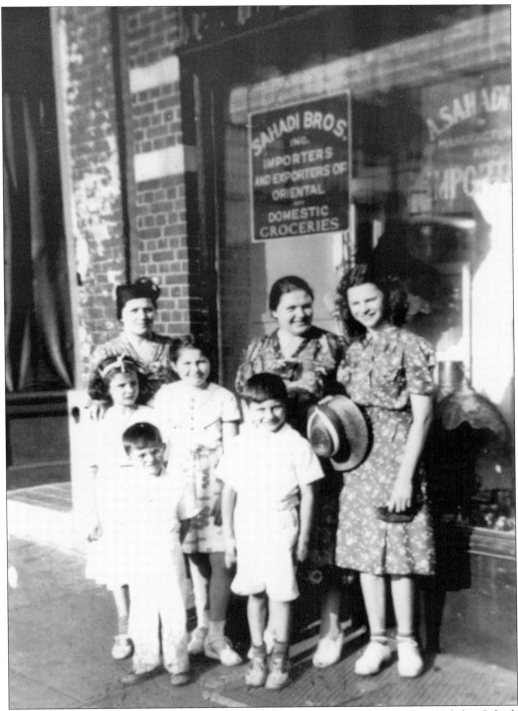

In this photograph, the Vislocky and Ochlan families are standing in front of the Sahadi Brothers grocery store, on Washington Street. The store was owned and operated by a Downtown Lebanese family. (Courtesy of Anna Salony.)

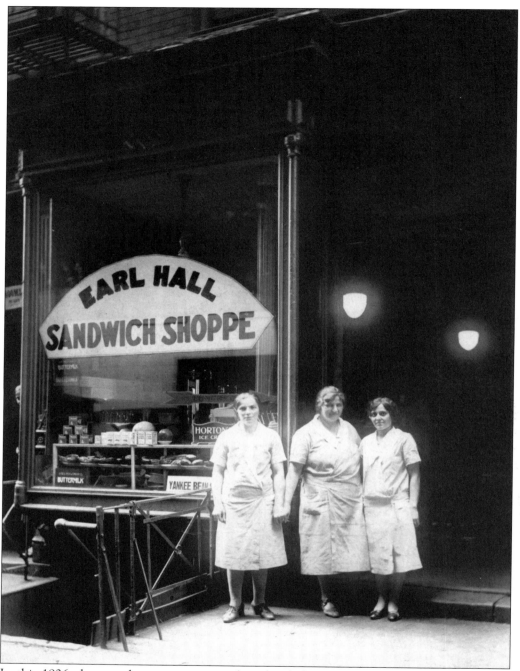

In this 1926 photograph, young women take a break from work at the Earl Hall Sandwich Shoppe, on Greenwich Street.

This photograph was taken in 1945 in front of Scotties Restaurant, at 57–59 Greenwich Street.

Several young men are pictured on a Sunday afternoon in 1949, shooting dice against a Tomecek's storefront on Albany Street. (Courtesy of Martin and Barbara Rizek.)

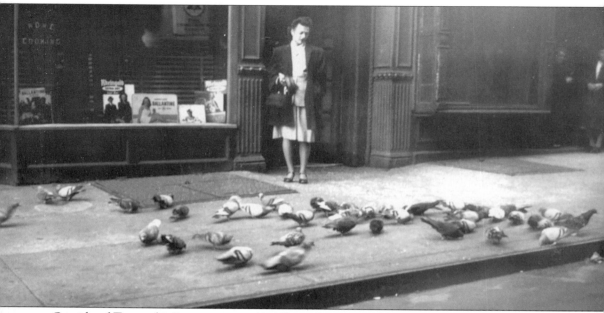

Outside of Tomecek's Restaurant, at 11 Albany Street, neighborhood resident Mary Yanoscik feeds the pigeons on September 28, 1947. (Courtesy of Mary Medvecky.)

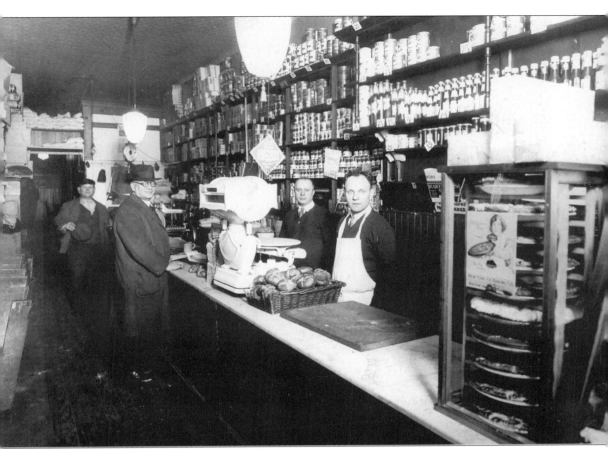

John Mica (left) and Paul Slezak are shown behind the counter in their grocery store at 66 Greenwich Street in 1925. In 1931, Slezak expanded his store to include a restaurant. In 1947, the restaurant moved to a new location at 142 Greenwich Street due to the building of the Brooklyn Battery Tunnel. The business remained at this location until 1971, when it was forced to close because of the building of the World Trade Center. (Courtesy of Joan O'Connor.)

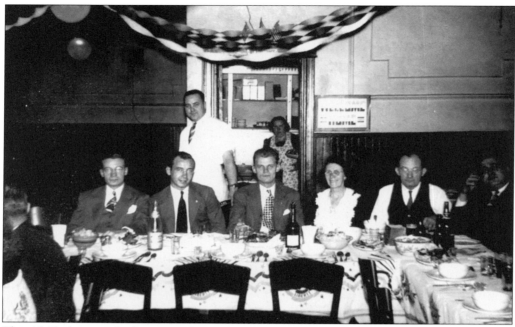

This 1945 photograph shows a welcome home party for Stephen Podzamsky, a World War II veteran and a World War II power turret gun sight specialist and mechanic. The family lived at 63 Greenwich Street. From left to right are brothers John, Paul, and Stephen; parents Anna and Stefan; and friend John Hornak Sr. The Podzamsky family lived at 63 Greenwich Street. (Courtesy of Stephen Podzamsky.)

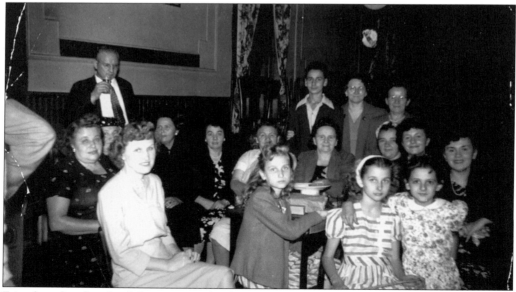

Friends gather for a birthday party at Slezak's, at 66 Greenwich Street. This was one of the local restaurants that held different functions for the people who lived in the community.

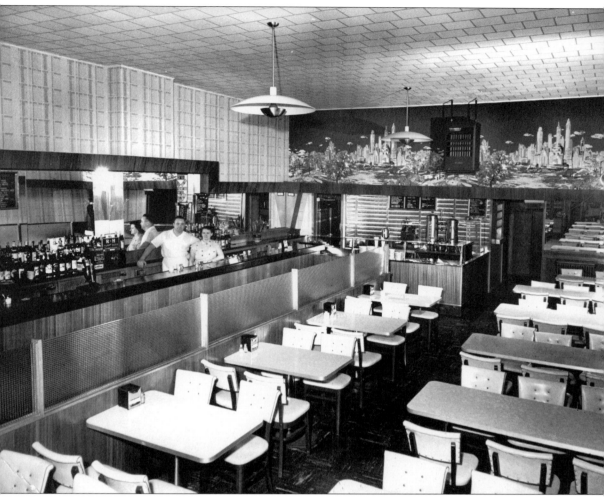

Pictured is the opening of Slezak's at its new location, 142 Greenwich Street, in 1947. (Courtesy of Joan O'Connor.)

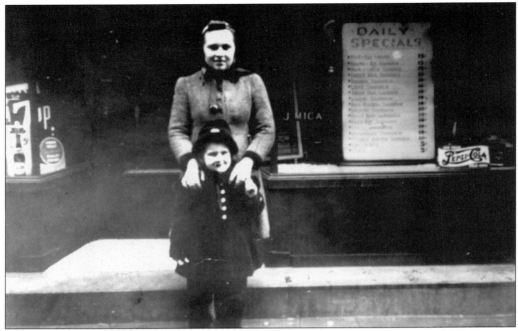

Joan Praskać (front) and Emily Mica stand in front of Mica's Sandwich Shop, at 149 Washington Street. John and Anna Mica, who lived in the neighborhood, owned and operated the shop. This photograph was taken in 1947. (Courtesy of Anna Praskać.)

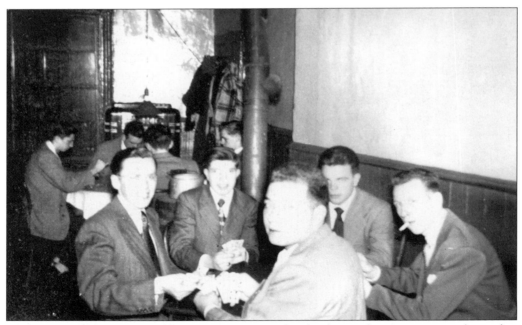

George's Candy Store, owned by George Knieser, a local Lebanese businessman, was located at 7 Albany Street. This photograph, taken in 1949, shows neighborhood teenagers playing cards around a potbellied stove. (Courtesy of Martin Rizek.)

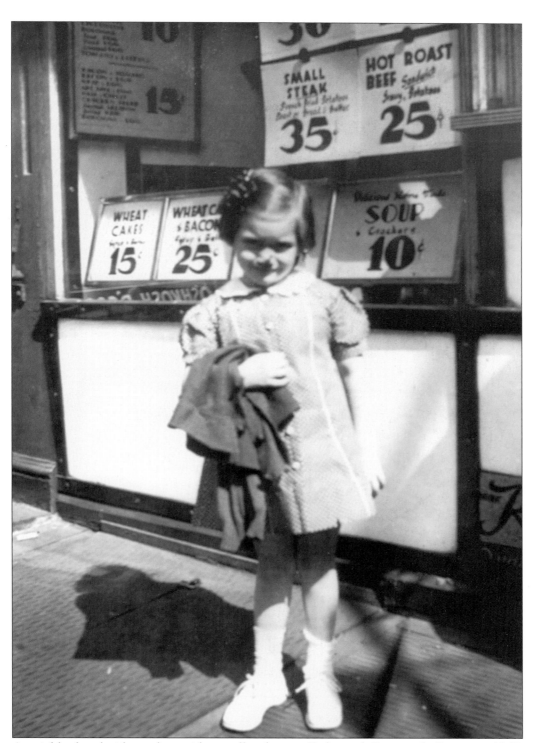

A neighborhood girl stands outside a coffee shop at Cedar and Greenwich Streets in 1942. (Courtesy of John Taaffe.)

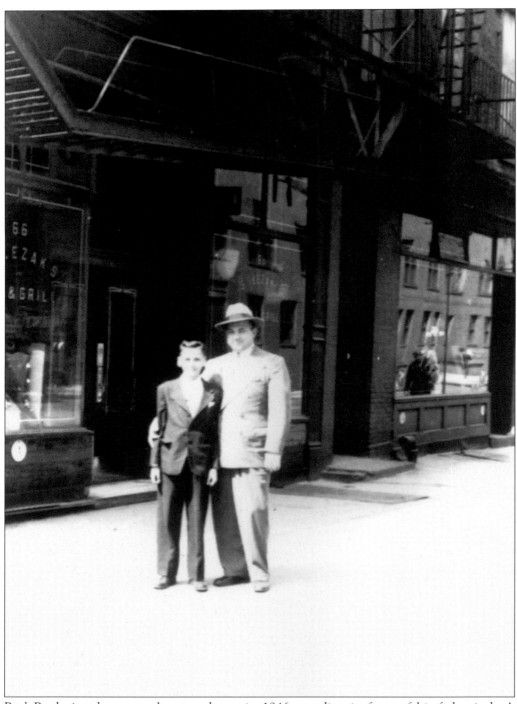

Paul Praskać and a young boy are shown in 1946, standing in front of his father-in-law's business, Slezak's, at 66 Greenwich Street. (Courtesy of Anna Praskać.)

Three

CULTURE

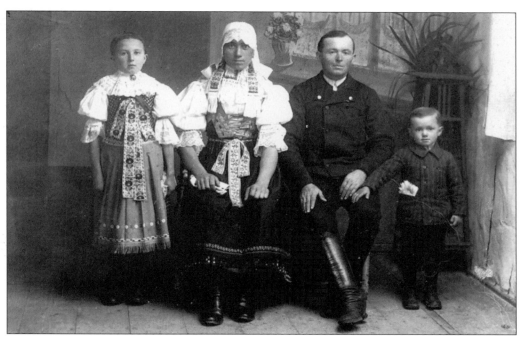

This is a family portrait of recent arrivals from Castkov, Slovakia. The family moved to 66 Greenwich Street. Notice the handkerchief in the girl's hand and also in the mother's hand. The father is in his riding boots, and the son is holding his father's knee. (Courtesy of Anna Praskać.)

Photograph of bearer

Description of bearer

Height 5 feet 1 inches.
Hair *Brown.*
Eyes *Blue.*

Distinguishing marks or features:

Place of birth *New York N.Y.*
Date of birth *May 21 1906.*
Occupation *Farming.*

Anna Skodaček
Signature of bearer.

#1

This is to certify that the attached photograph bears the signature and is a likeness of the person to whom this passport is issued. In witness whereof, the seal of the Department of State is impressed thereon.

CANCELLED

Sisters Anna and Susie Skodacek arrived in New York in 1926. Anna's passport is shown here.

The Skodacek sisters, Anna (right) and Susie (below), happily settled in their new residence at 65 Greenwich Street.

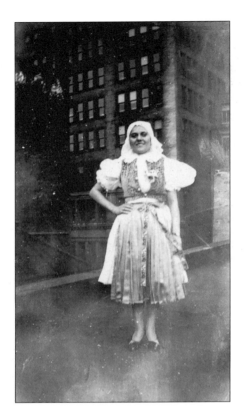

A young girl is pictured on the rooftop at 65 Greenwich Street in 1926. She is dressed in her native clothing from Vrbovce, Slovakia. (Courtesy of Martin and Barbara Rizek.)

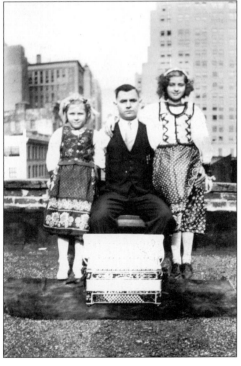

Peter Ceselka, a proud father, is pictured with his daughters Helen and Mary. Their accordion is displayed in front of them on a rooftop on Albany Street. Helen later became the director of the Troika Balalaika Orchestra. (Courtesy of Frank and Mary Zizik.)

On their way to a party, the Vislocky family poses for a picture on the roof of 17 Trinity Place in 1934. The family came from Litmanova, Slovakia. (Courtesy of Michael Vislocky.)

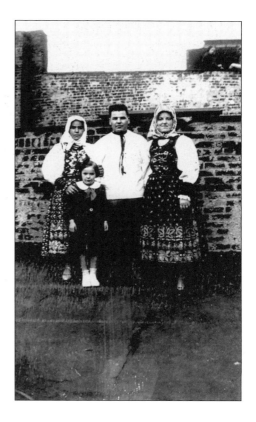

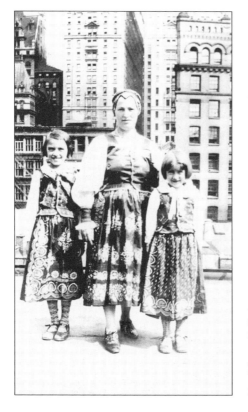

Anna Yanoscik and her two daughters, Mary (left) and Anna (right), are shown standing on the rooftop of 9 Albany Street. Each costume design (colors, patterns, and trimmings) was distinctive and used to identify the towns they were from. These costumes were from the village of Jarabina, Slovakia. (Courtesy of Mary Medvecky.)

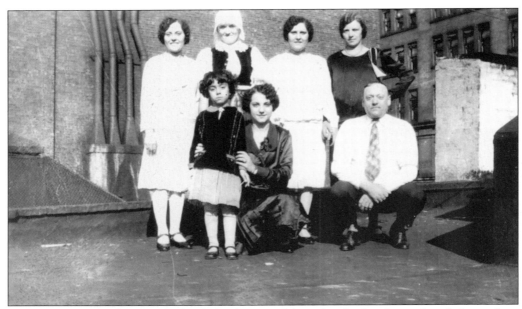

In the summer of 1926, the Skodacek family arrived from Czechoslovakia and settled into their new home at 65 Greenwich Street. In the background are the skyscrapers of lower Broadway.

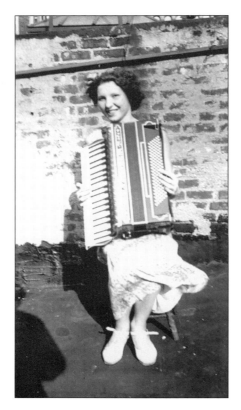

Mary Rusinak is on an Albany Street rooftop in 1936, holding an accordion belonging to Michael Yanoscik. His name was engraved in pearl along the edge of the accordion. (Courtesy of Mary Medvecky.)

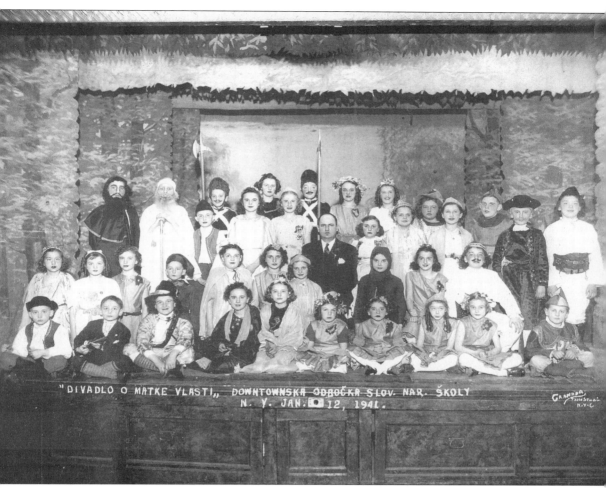

"DIVADLO O MATKE VLASTI„ DOWNTOWNSKA ODBOČKA SLOV. NAR. ŠKOLY
N. Y. JAN. 12, 1941.

On January 12, 1941, students of the Slovak National School, Downtown Chapter, at 25 Thames Street between Trinity Place and Greenwich Street, perform in a play, which was an annual event in the neighborhood.

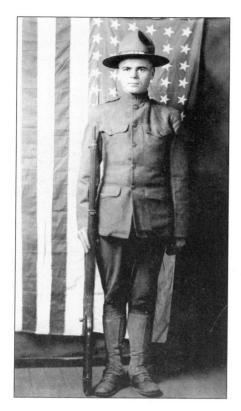

This portrait of Martin Rizek Sr. was taken in 1917. He arrived in America in 1910 at the age of 16. In 1917, during World War I, he joined the U.S. Army. Rizek was a violinist and author who wrote poems, short stories, and articles for the *New Yorsky Denik*, a New York–based Slovak newspaper. Martin formed the Downtown Band, which performed at many local affairs and picnics.

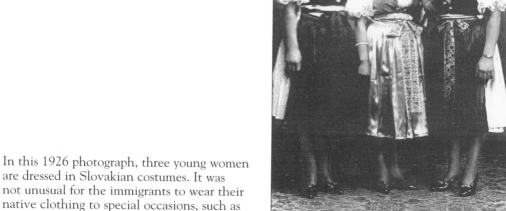

In this 1926 photograph, three young women are dressed in Slovakian costumes. It was not unusual for the immigrants to wear their native clothing to special occasions, such as weddings and dances.

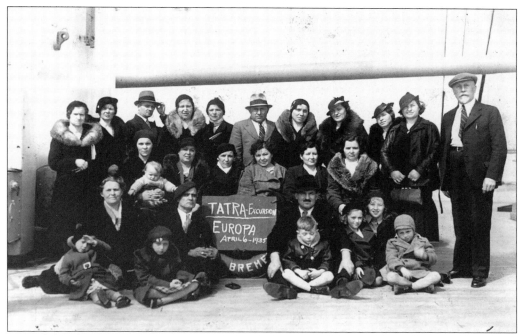

Several families from Downtown get ready to board the ship *Bremen* on April 6, 1935. The group is returning to Slovakia for a visit.

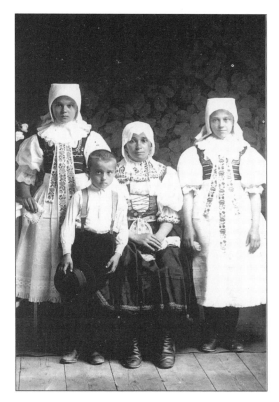

This family from Castkov, Slovakia, arrived in America in 1929 and lived at 65 Greenwich Street for a short period of time, but they were forced to return to their native land. Many immigrants traveled back and forth to their homeland before finally settling in the United States.

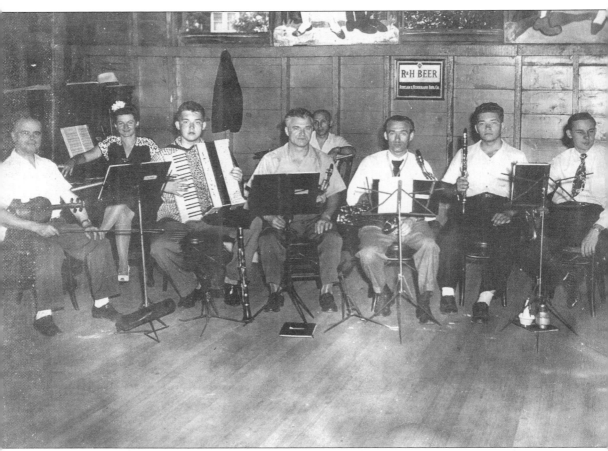

In addition to Downtown weddings and dances, the Downtown Slovak Band often played at picnics. In this photograph, they are performing in Grant City, Staten Island, in 1946. The musicians are, from left to right, Martin Rizek Sr. (violin), Anna Peles (piano), Eddie Jozefek (accordion), John Krasikar (drums), John Jozefek Sr. (saxophone), John Krasikar (saxophone), John Jozefek Jr. (clarinet), and Paul Kovalcek (trumpet). (Courtesy of Martin and Barbara Rizek.)

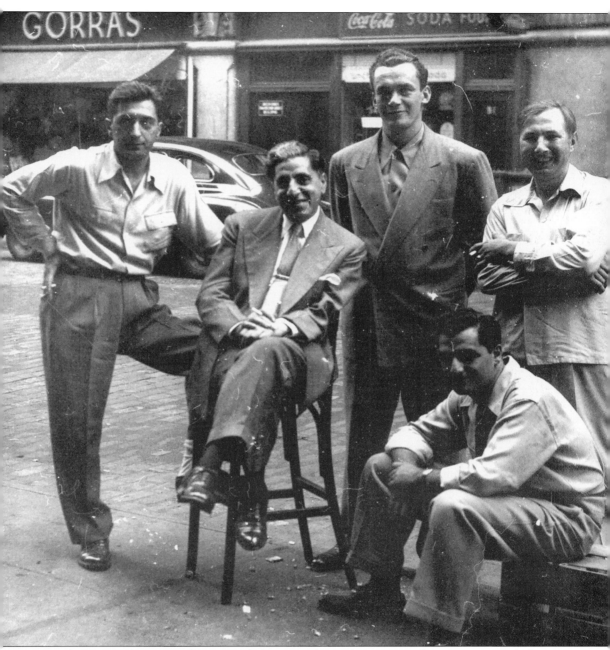

On the corner of Rector and Greenwich Streets in front of Gorra's, a Lebanese women's clothing store, are five Downtown men representing five different ethnic groups: Greek, Lebanese, Slovak, Irish, and Polish. From left to right are the following: (standing) John Constantine (Greek), John Taaffe (Irish and Slovak), and Walter Sliva (Polish); (sitting) Louis Karem (Lebanese) and Joe Boulos (Lebanese.)

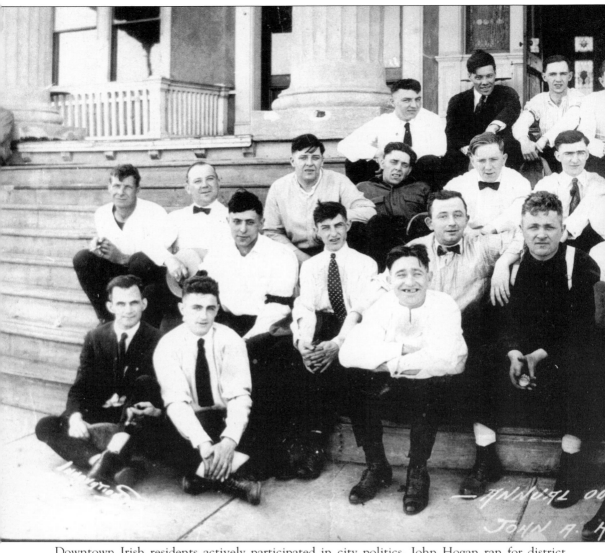

Downtown Irish residents actively participated in city politics. John Hogan ran for district leader of the Democratic Party for the First Ward. Each year, the Hogan's Association, a

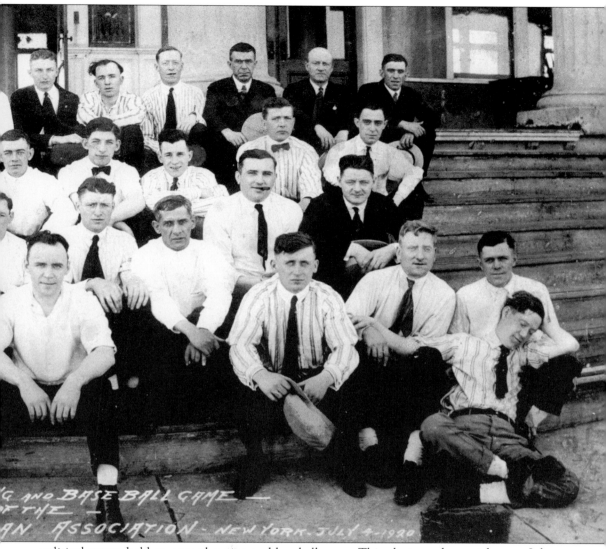

...G AND BASEBALL GAME —
...F THE —
...AN ASSOCIATION - NEW YORK - JULY 4 - 1920

political group, held an annual outing and baseball game. This photograph was taken on July 4, 1920, following the get-together. (Courtesy of John Taaffe.)

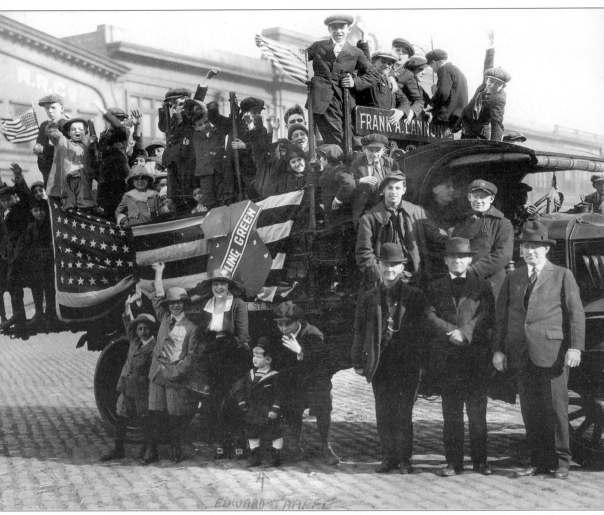

In this 1917 photograph, residents from the lower west side area join together at a political rally. The mostly Irish group is standing on a truck belonging to Frank A. Lannon. The boy in the sailor suit at the bottom of the picture is Edward Taaffe, who lived with his parents, Anna and John Taaffe, at 21 West Street. (Courtesy of John Taaffe.)

Four

RELIGIOUS LIFE

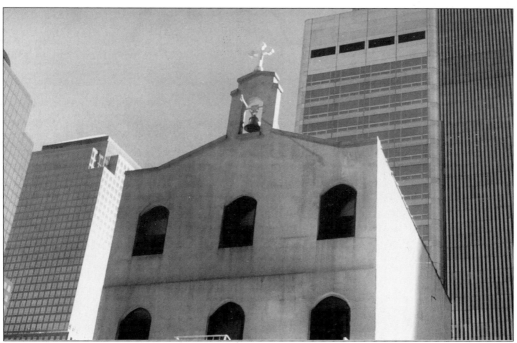

The Greeks from Downtown attended services at St. Nicholas Greek Orthodox Church, at 155 Cedar Street. The building was not always used as a church. At first it was a private home built in 1832. In 1920, the building housed a tavern named the Cedar House. Because of Prohibition, the tavern closed. The community of St. Nicholas Greek Orthodox Church bought the building in 1922. Parishioners traveled from a distance for Sunday services up until September 2001. The attack on the World Trade Center and the fall of the South Tower destroyed the little church. Plans are now being made to rebuild close to the original site. (Courtesy of James Maniatis.)

Shown in this photograph is the interior of St. Nicholas Greek Orthodox Church. Parishioners are attending a memorial service. On the extreme right is Theodore Maniatis Sr., president of the church. In a bow tie is Michael Paulakos, church secretary. Parishioner George Margetis is standing behind the unidentified women in a kerchief. (Courtesy of James Maniatis.)

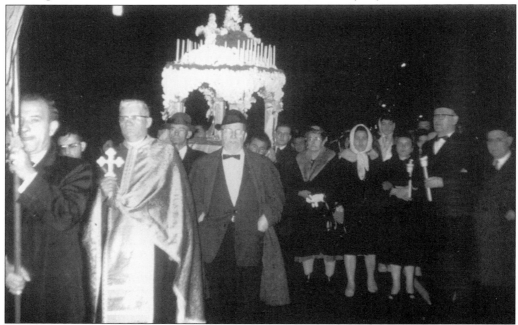

Parishioners of St. Nicholas Greek Orthodox Church are shown marching down Greenwich Street during a Good Friday service procession. Rev. John Vournakis is at the beginning of the procession, holding a cross. (Courtesy of James Maniatis.)

As part of Epiphany services, the congregation marches down West Street to Battery Park pier to celebrate the blessing of the water. Behind the marchers is the World Trade Center. The volunteer band includes Andrea Fotopoulos (clarinet), Angelo Karopodis (bass drum), Laki Fotopoulos (small drum), and Chris Fotopoulos (trumpet). (Courtesy of James Maniatis.)

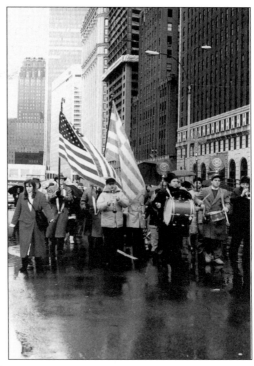

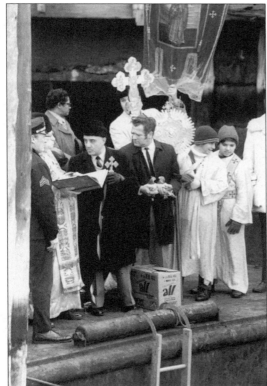

During the blessing of the waters, a cross is cast into the river, and divers jump in to retrieve it. Rev. John Vourankis is shown reading a Bible. James Maniatis holds the cross while George Alexander is ready to release doves after the cross is thrown into the river. (Courtesy of James Maniatis.)

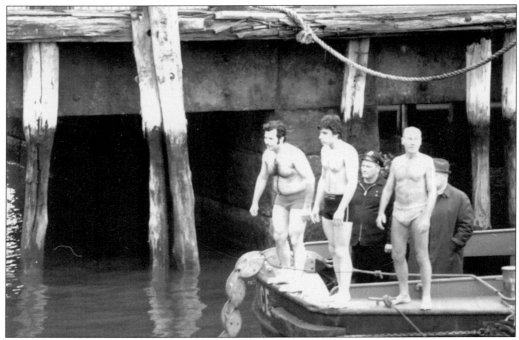

Theodore Maniatis (center) is pictured with two other volunteers ready to dive for the cross. (Courtesy of James Maniatis.)

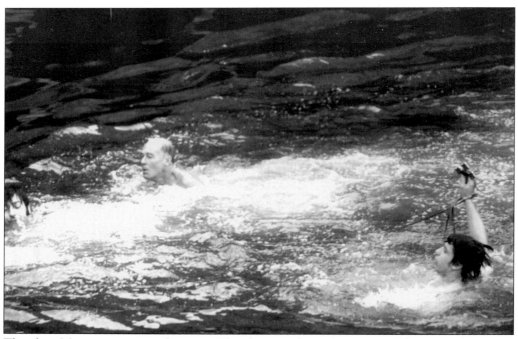

Theodore Maniatis retrieves the cross. Theodore was born in Lower Manhattan and is now a doctor and pulmonary specialist at Staten Island Hospital.

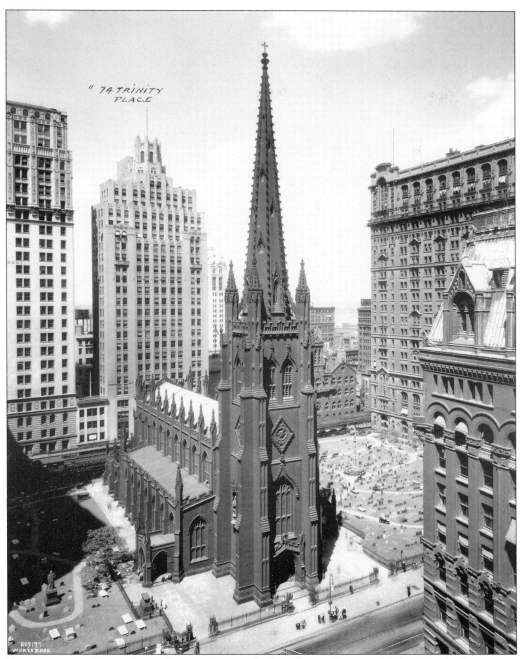

Downtown residents admittedly owe a great deal to Trinity Episcopal Church, which was one of the cornerstones of their community life. Although many were not practicing Episcopalians, residents received spiritual and social assistance from the church. The beautiful present-day Gothic Revival structure, pictured here in 1942, was designed by Richard Upjohn and consecrated in 1846. It is the third building to occupy its current location at Broadway and Wall Street. King William III of England originally founded the parish in 1697. (Courtesy of the Parish of Trinity Church of the City of New York.)

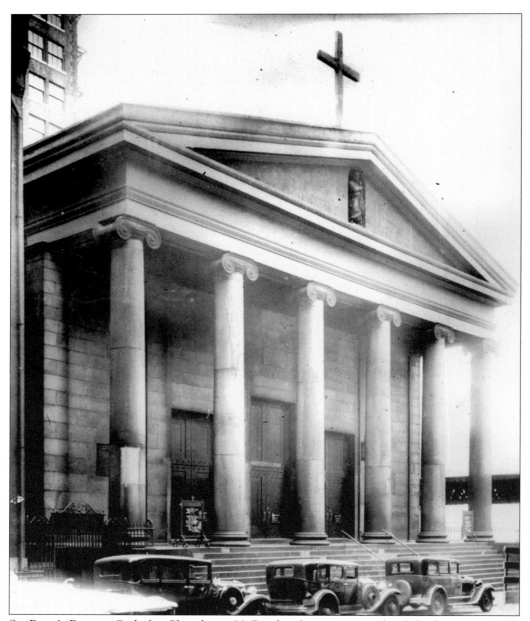

St. Peter's Roman Catholic Church, at 22 Barclay Street just north of the lower west side neighborhood, figures prominently in American Roman Catholic history. Founded in 1785, St. Peter's is the oldest Catholic parish in New York State. Two prominent New York City residents, who were later elevated to sainthood, attended St. Peter's: Elizabeth Ann Seton, who founded the Sisters of Charity, and Pierre Toussant, a former slave and successful African American businessman. The present-day Greek Revival granite building, pictured here, was built in 1836.

Parishioners stand in front of St. Joseph's Maronite Church, at 57–59 Washington Street, in 1942. The church was originally founded in 1890 as the first Maronite Mission to the United States. Church services were celebrated at that time in a rented hall at 127 Washington Street. The parish then moved to 81 Washington Street and in 1910 to the location pictured here.

With the advent of the building of the Brooklyn Battery Tunnel, the parish was forced to move, this time to 157 Cedar Street (now the corner of Cedar Street and the Westside Highway). Eminent domain prevailed for a second time with the construction of the World Trade Center, and the church was again relocated to 385 South End Avenue in the Gateway Plaza Apartments in Battery Park City. (Courtesy of Marian Sahadi Ciaccia.)

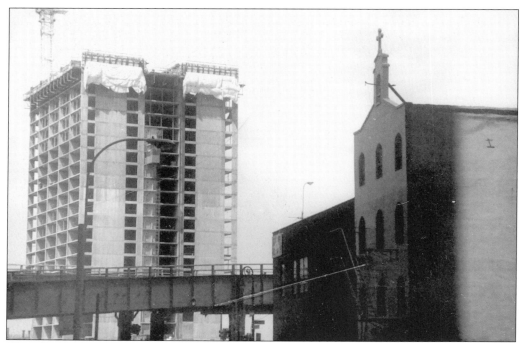

This photograph shows St. Joseph's Maronite Church, at 157 Cedar Street next to St. Nicholas Greek Orthodox Church. In the background is the construction of Gateway Plaza, which was the first apartment complex in Battery Park City.

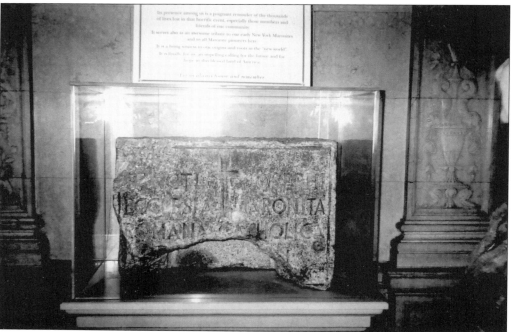

This cornerstone from St. Joseph's Maronite Church was recovered after September 11, 2001. (Courtesy of Marian Sahadi Ciaccia.)

Lou Sahadi (left) and George Buzhar pose
in Battery Park after receiving First Holy
Communion at St. Joseph's Maronite Church.
Sahadi is a sportswriter for the Miami Herald and
a published author. Buzhar's parents ran a lingerie
business on Washington Street. (Courtesy of
Marian Sahadi Ciaccia.)

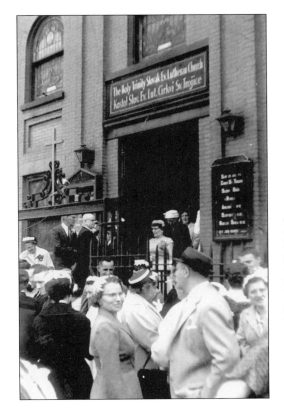

The Slovak Lutheran community of Lower
Manhattan attended Holy Trinity Slovak
Lutheran Church, at East 20th Street and
First Avenue. Parishioners traveled to the
church via the Lexington Avenue subway
line to Union Square Station at 14th Street
and walked the remaining seven and a half
blocks to the church. Founded in 1902,
the church recently celebrated its 100th
anniversary. Still an active parish, the
church has services in both English and
Slovak each Sunday. (Courtesy of Martin
and Barbara Rizek.)

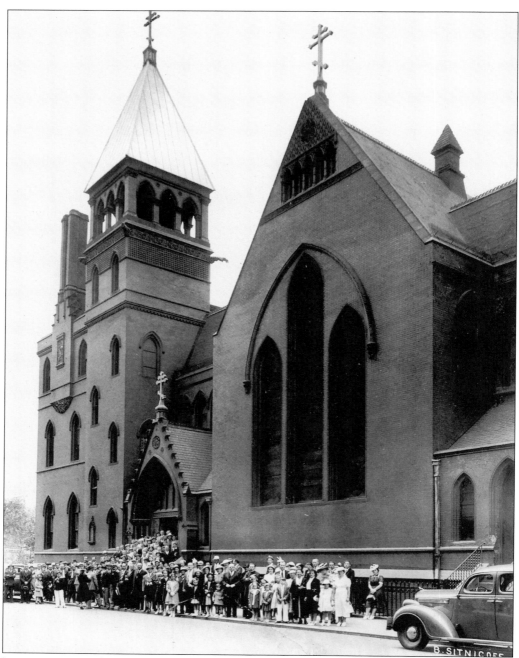

It was not unusual for residents to attend churches in other parts of the city. The Carpatho-Russian Orthodox Downtown community belonged to St. Nicholas Orthodox Church, located at 288 East 10th Street and Avenue A on the Lower East Side. In 1936, the parish members purchased this beautiful building, originally built in 1884 as a mission chapel to St. Marks-in-the-Bowery Episcopal Church. Renowned architect James Renwick Jr., who designed St. Patrick's Cathedral and St. Bartholomew's Episcopal Church in Midtown Manhattan, designed this mission chapel. (Courtesy of John E. Petrick.)

Five

COMMUNITY SERVICES AND EDUCATION

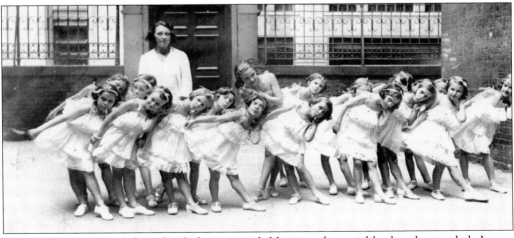

Public School 29 was the school that most children in the neighborhood attended. It was located at Albany and Washington Streets. In this 1930s photograph, a class of young girls is performing in a dance recital in the girls' schoolyard. (Courtesy of Mary Medvecky.)

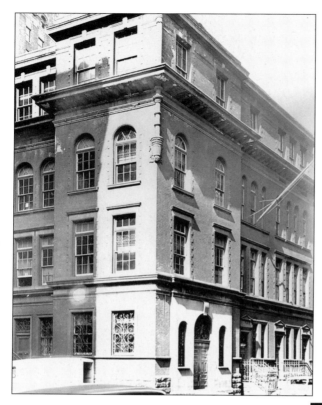

This is a view of Public School 29 from the corner of Albany and Washington Streets in 1940. The entrance faced Albany Street. Many of the students who attended were children of immigrants, and English was their second language. The school was razed in 1963, and a parking lot stood in its place for many years. Today, the Marriott Hotel stands on the spot where the school once stood.

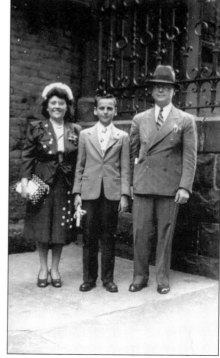

Proud parents pose with their son in front of Public School 29 in 1946. The young graduate is holding his diploma in his right hand.

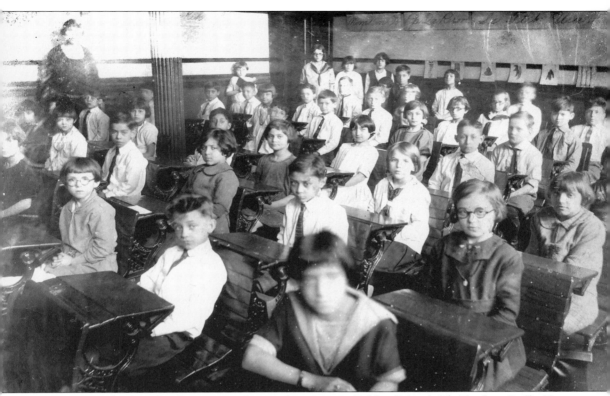

This 1926 third-grade class is seated in a classroom in Public School 29. Teacher Stella K. Hamell is shown standing in the left corner of the photograph. (Courtesy of Barbara Rizek.)

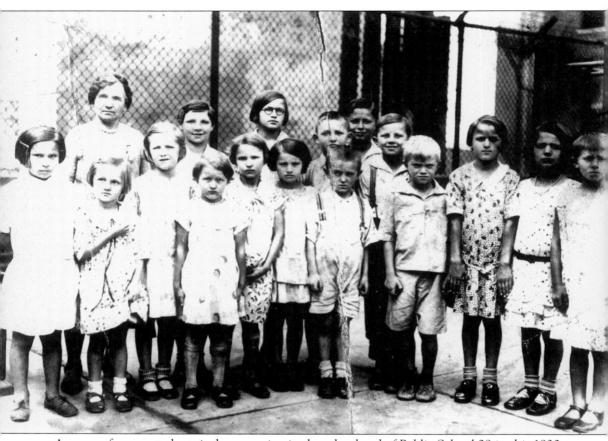

A group of young students is shown posing in the schoolyard of Public School 29 in this 1930s photograph. The Downtown immigrant parents wanted their children to appreciate their culture, yet assimilate, learn English, and receive an education. Many children went on to high school and college and became successful later in life.

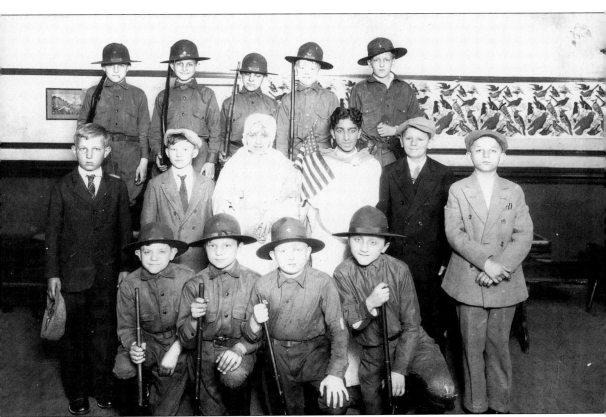

In the assembly hall of Public School 29, students dressed in costumes have just finished a school performance. The boys are outfitted in World War I–style military uniforms. (Courtesy of Angela Kindya.)

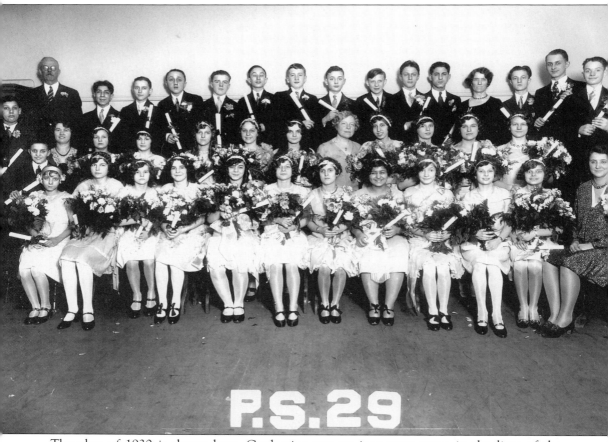

The class of 1930 is shown here. Graduation was an important event in the lives of the Downtown residents. Flowers were given to the graduating students and to the teachers. The teachers had corsages, the boys had lapel flowers, and the girls had bouquets.

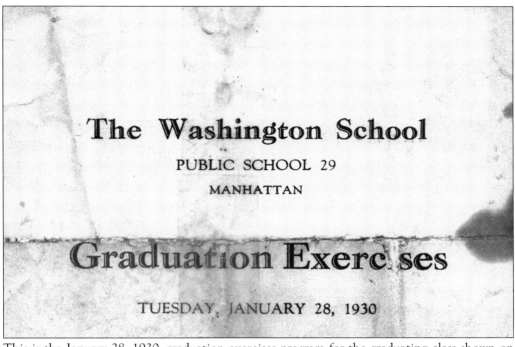

The Washington School

PUBLIC SCHOOL 29

MANHATTAN

Graduation Exercises

TUESDAY, JANUARY 28, 1930

This is the January 28, 1930, graduation exercises program for the graduating class shown on the previous page. Graduation was held twice a year—in January and June. (Courtesy of John and Katherine Taaffe.)

GRADUATES

Abouhedar, Josephine
Assad, Secy
Donam, Mary
Florek, Elizabeth
Florek, Esther
Hatarik, Bertha
Jarembinsky, Mary
Kozik, Anna
Kelcho, Stephanie
Mikulee, Lily
Nacin, Maria
Nakoneczna, Julia
Ruqus, Mary
Sienkiewicz, Mary
Sikora, Margaret
Slezak, Anna
Stefanak, Anna
Weil, Lillie

Wira, Anna
Zehall, Anna
Bettick, Joseph
Duda, John
Fedak, Charles
Haddad, Nicholas
Hrinyak, Joseph
Jacobs, Charles
Karpiscak, Samuel
Kawaja, John
Malast, Michael
Najar. Philip
Redecha, John
Steffik, Samuel
Taafe, Edward
Wajtonicz, Peter
Zabriskie, Walter

The graduates' names were listed in the back of the program. The last names show the diversity of nationalities that attended the school downtown. (Courtesy of John and Katherine Taaffe.)

Program

SCRIPTURE READING

HYMN—"America, the Beautiful"........................School

SAFETY PROGRAM

IN HEALTH
Play: "A Day in Happy Land"....................5A4 and 3A3

ON STREETS
(1) Origins, Playlet by Teacher of....................3B and 1A
(2) Prize-Winning Composition................Peter Wajtonicz
 Medal Given by National Highway Board, Washington, D. C.

IN CHOICE OF FRIENDS
Play: "The Little Pilgrim's Progress"................6B and 5B

IN RECREATION
(1) Clog Dance...............................8B Boys
(2) Chorus....................................7th Year Boys
(3) Game......................................6th Year Pupils

IN DEMOCRACY
Play: "America—Democracy's Goal"......8th, 7th 6th, and 5th Years
Dance...8th Year Girls

FLAG SALUTE
"Star Spangled Banner"

Program

G. HYMN (four-part) "Cast Thy Burden on the Lord".........Scho

4. PRESENTATION OF MEDALS

A. General Excellence (B.G.N.A.) Gold..............Peter Wajtoni

B. General Excellence (B.G.N.A.) Silver..................Lillie We

C. Sewing (B.G.N.A.)................................Esther Flore

D. Home Making................................Mary Don

E. Shop..Edward Taa

F. Theodare Roosevelt Memorial Assoc. Medal........Peter Wajtoni

G. Safety Medal—Bureau of Fire Prevention
 Tessie Diet Marion Smith
 Michael Huykala Lillie Weil

H. Personal Hygiene............Mary Jarembinsky, Nicholas Hadd

5. ADDRESS...........................Dr. Loretto M. Rochest

6. PRESENTATION OF DIPLOMAS

7. "AMERICA"

The inside of the graduation program is shown here. Exercises began with a scripture reading, followed by the hymn "America the Beautiful." Students from other classes performed plays and dances. The boys' chorus was from the seventh-year class. Medals were given out for general excellence, sewing, homemaking, shop, safety, and personal hygiene. (Courtesy of John and Katherine Taaffe.)

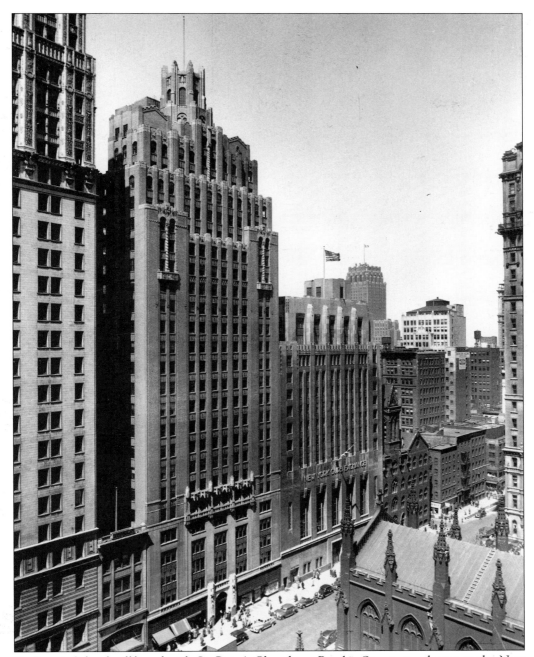

St. Peter's School, affiliated with St. Peter's Church on Barclay Street, stood next to the New York Curb Exchange. The school, located at Trinity Place and Cedar Street, opened its doors as the first Catholic school in New York State in 1800. Many children from the lower west side neighborhood attended St. Peter's until it closed in 1947 because of a decline in the number of residents living downtown.

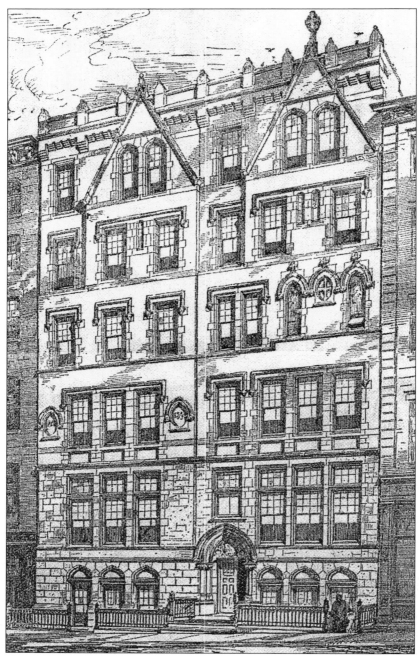

Trinity Mission House was founded in 1876 to assist the poor immigrant communities that settled in Lower Manhattan. The mission was first located at 3 Morris Street and then moved to 20 State Street (the address number was subsequently changed to 30 State Street). Due to an increase in rent and what was considered an inconvenient location because it was situated at the southern end of the neighborhood, the mission was moved in 1887 to 211 Fulton Street (as shown in this sketch), where it remained until it closed in 1955. It housed a dispensary, chapel, kindergarten, and guild rooms. (Courtesy of the Parish of Trinity Church of the City of New York.)

Trinity Church organized associations for the Downtown community's young adults: St. Stephen's Guild for the boys and St. Mary's Guild for the girls. This photograph shows young couples dancing at a Saturday night social sponsored by St. Stephen's Guild in 1957. The dances, which were held each month at 74 Trinity Place, were popular with the community's young people. Rev. Cannon Charles Bridgeman chaperoned.

St. Stephen's Guild held parties for the neighborhood's young adults. Fr. Charles Asa Clough, guild chaplain, is surrounded by guild members at a Christmas party on December 12, 1936, in the Club Room at the Trinity Mission House, at 211 Fulton Street. (Courtesy of Angela Kindya.)

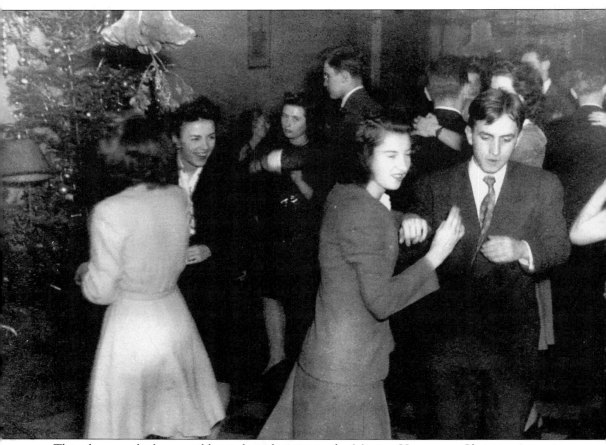

This photograph shows guild members dancing in the Mission House at a Christmas party in 1943. (Courtesy of Peter Balas.)

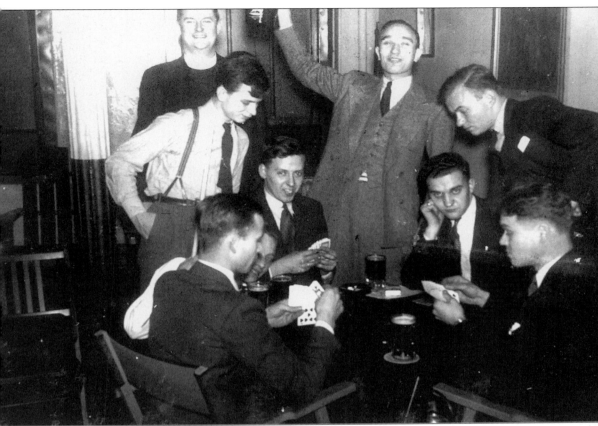

It is a typical evening at the Trinity Mission House. These St. Stephen's Guild members are playing cards while Father Clough oversees the game.

Shown in these two pictures is the May 31, 1938, dress rehearsal for the theatrical revue *Extra! Extra!* Revues usually ran for two nights at the Trinity Mission House. Neighborhood residents attended for a small admission fee. The skits were *The Bigamist* (above) and *Woman Makes News* (below). (Courtesy of Angela Kindya.)

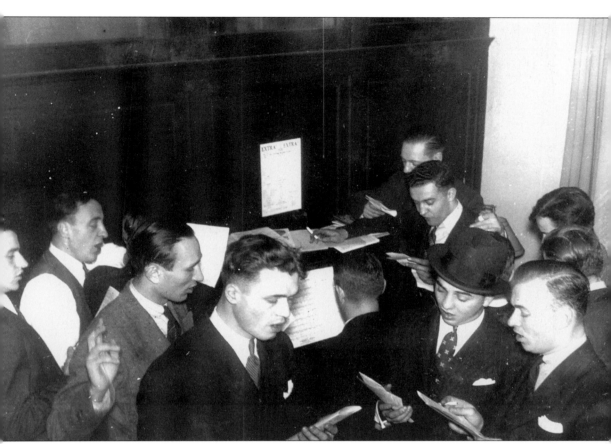

Members are rehearsing in 1938 for *Extra! Extra!*, one of the numerous annual revues presented by St. Stephen's Guild from 1931 to 1938. Humorous one-act plays, comedy skits, and songs were performed under the direction of Father Clough, who was a member of the Yale University Drama Club during his college years. (Courtesy of Angela Kindya.)

Believe It or Not

A Revue in Eight Acts

◎

Presented by

St. Stephen's Guild

◎

Trinity Mission House
May 17, 1932
May 18, 1932

This is the cover of the program for 1932 revue *Believe It or Not*, which was performed by St. Stephen's Guild members. (Courtesy of the Parish of Trinity Church of the City of New York.)

Cast

PART ONE

Act I—BELIEVE IT OR NOT
Bill the Booster John Pryka
Dot .. Otto Mikulec
Dash ... Stanley Bucker
Chorus...........John Bourlet, Charles Jacob, George Pekurny,
Bela Fiscor, Michael Zihal, Joseph Kindya, Martin Pekurny

Act II—MOVING BECOMES ELECTRIC
Husband John Tevas
Wife ... Frederick Hinrichs
Mover I Stephen Fiscor
Mover II Joseph Dupcak
Mover III George Grobouski
Scene: An Apartment in the Bronx.

Act III—COLLEGE DAZE
Dick ... Bela Fiscor
Tom .. Michael Zadik
Harry .. John Pryka
Pat .. Paul Debaylo
Mike ... Stephen Fiscor
Spud ... Otto Mikulec
Professor Batty John Kanya
Scene: Campus of Wampus College.

Act IV—ROLLING STONES—A Play in One Act by John Kanya
Muffin, Butler to Lord De Vries............... Joseph Kindya
Varick Vandam Vanderbilt, of Vanderbilt and Ginsberg John Kanya
Isaac Ginsberg, of Vanderbilt and Ginsberg.......Stanley Bucker
Lord Geoffrey Algernon Cholmondeley De Vries......John Bourlet
Joe Gluts, House Detective George Grobouski
Scene: Apartment of Lord De Vries.

Act V—THROWING THE BULL—A Very Grand Opera
Hotcha Tamale John Pryka
Don Sauso Tobasco Anthony Grobouski
Alfonso Spagoni John Tevas
Senorita Chili Concarne Charles Mikulec
Three MatadorsOtto Mikulec, Michael Zadik, Bela Fiscor
The Bull George Pekurny
Scene: A Spanish Piazza.

The inside page of the revue program lists the performers of *Believe It or Not*.

On the left is Chuck Vislocky, and on the right is Paul Podzamsky, basketball players on the Albany Cubs basketball team. Home court was 107 Washington Street. Called the Boys Athletic League (BAL), they also played at the Downtown Athletic Club. The Albany Cubs played with different teams throughout Manhattan.

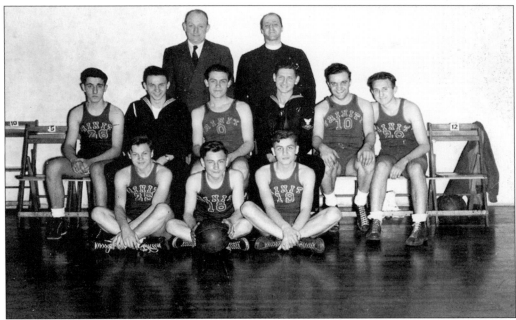

St. Stephen's Guild formed a basketball team for the Downtown teenagers and young adults. Neighborhood residents attended the games, which were usually held on Friday evenings. Admission was free. (Courtesy of the Parish of Trinity Church of the City of New York.)

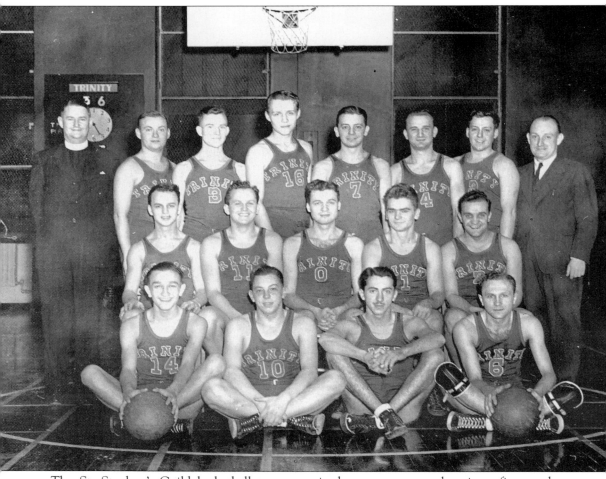

The St. Stephen's Guild basketball team practiced at two separate locations: first at the Bowling Green Neighborhood Association building, located at 107 Washington Street, and several years later at the Downtown Athletic Club, a private men's club located at 19 West Street. Seen in this late-1930s photograph are, from left to right, the following: (first row) H. Jacobs, J. Kania, M. Kania, and M. Yanoscik; (second row) ? Koch, J. Klimcak, N. Kobel, T. Matzik, and S. Steffek; (third row) Father Clough, S. Bucker, J. Kindya, D. Dupcak, J. Kania, A. Simak, J. Rudlak, and coach Red Ryan. (Courtesy of the Parish of Trinity Church of the City of New York.)

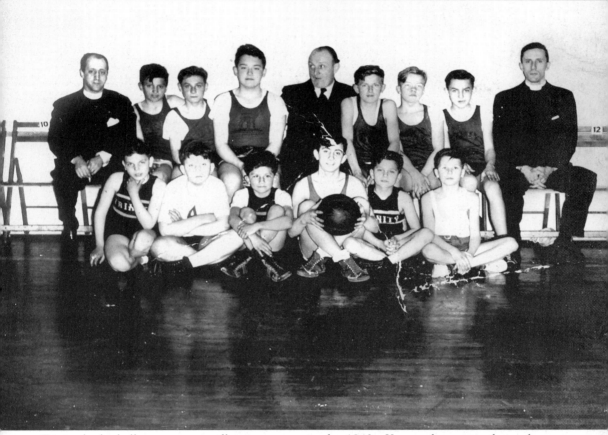

Trinity basketball teams were still going strong in the 1940s. Young players are shown here in 1945.

The 1957 St. Stephen's Guild basketball team stands in the locker room of a competing team after losing a close game. The boy in the front on the right is Roy Jung, whose parents owned a laundry at 135 Washington Street for many years.

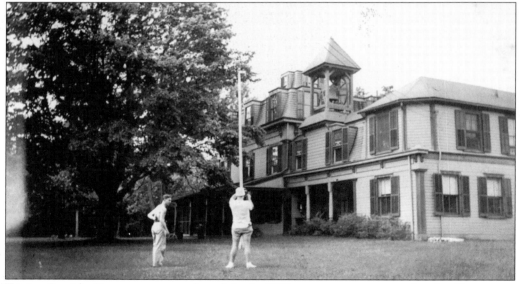

Trinity Seaside Home was opened on July 1, 1882, as a summer camp for the Downtown children. The camp was located on the east side of Great River, near East Islip, Long Island, on land donated by Mrs. William Kissam Vanderbilt. This photograph shows a camper raising a flag in front of the camp's main house on June 18, 1937. (Courtesy of Mary Medvecky.)

In this 1930s photograph, young boys from Downtown are standing on the beach at Great River just before a swim.

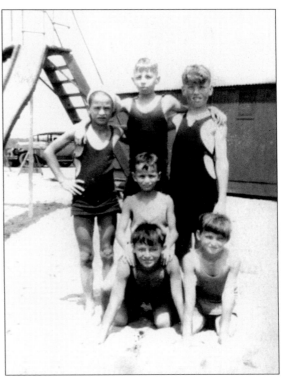

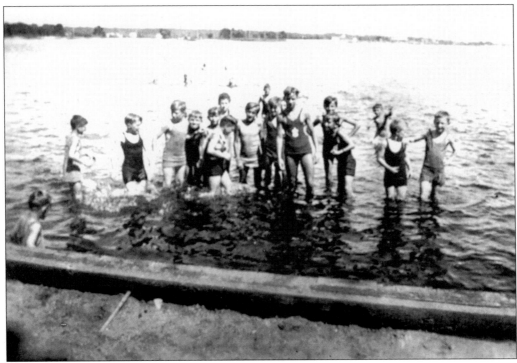

Young campers are shown swimming in Great River.

Fr. Asa Clough is relaxing on a lawn chair while watching a baseball game. (Courtesy of Mary Medvecky.)

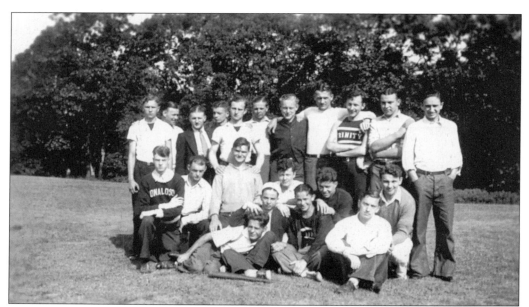

Shown in this photograph is a group of campers from the neighborhood on the lawn at the Trinity Seaside Home. Note the young man in the back row, third from the right, wearing a shirt with the Trinity logo.

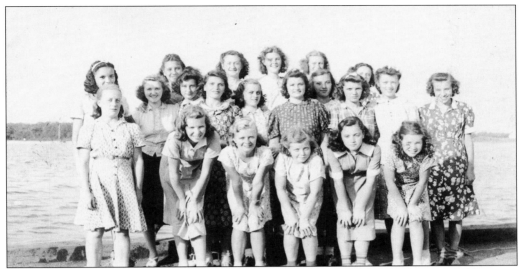

A group of young girls is shown posing along the edge of Great River in the 1930s. (Courtesy of Mary Medvecky.)

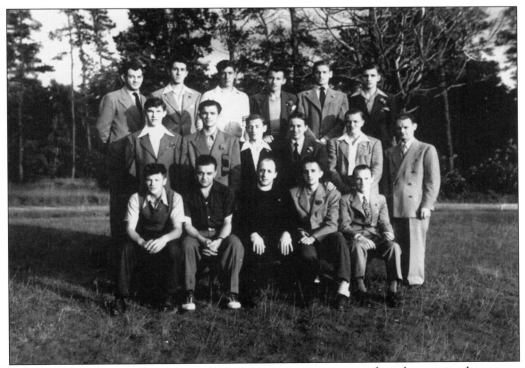

Campers pose for one last picture before leaving to return to their homes in downtown Manhattan. Camp sessions usually ran for one week. Father Good is sitting in the center in the first row.

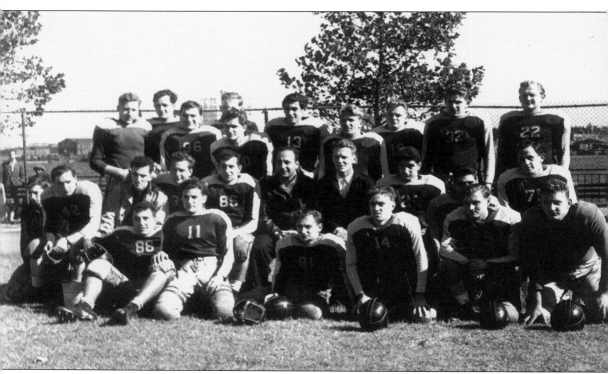

The Catholic Youth Organization (CYO) of St. Peter's Church, located at Trinity Place, organized the St. Peter's Downtown football team in 1948. The team played in the church league and competed against a number of teams throughout the city, including St. Mary's and St. James'. The league lasted three years. Included in this photograph are Frank "Red" Kulaya, Harry Ochlan, Steve Baran, John Ochlan, Johnny Sladek, Andrew "Shorty" Stack, John "Derro" Derevjanik, Joey Derevjanik, Willie "Whitey" Korchak, Jimmy McMahon, Joey Baran, Louie Shalhoub, Johnny "Lindy" Kormanik, Alex "Roosh" Rusinak, Georgie Calas (in a suit), John Hajjar, George Hajjar, Johnny "Fatso" Baran, Dave "Big Dave" Srour, Sonny Dillon, John "Glass Arm" Gaydos, Mikey "Crow" Cox, Charlie "Mousie" Gaydos, and Bobby "Beefo" Simak. (Courtesy of Charles Gaydos.)

John "Buster" Hornak (the only player not in the group photograph) lived at 63 Greenwich and helped organize the league. (Courtesy of Mary Fackovec.)

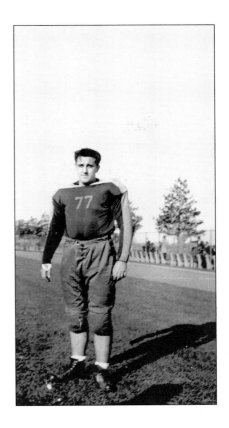

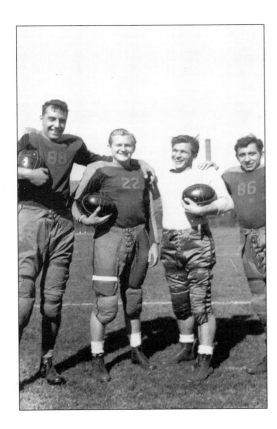

St. Peter's Downtown football players are shown here after practice. (Courtesy of Mary Fackovec.)

BROAD STREET HOSPITAL—Out Patient Department
129 BROAD STREET, NEW YORK
TELEPHONE BOWLING GREEN 9-3030

NO. 6537

NAME Taaffe P

AGE

ADDRESS

DEPT. SURGICAL

DATE

DEPT.

DATE Daily 10-12
2-3.30

ALWAYS BRING THIS CARD WITH YOU

CLINIC OPEN DAILY FROM EXCEPT SATURDAYS,
SUNDAYS AND HOLIDAYS

EMERGENCY CASES TREATED AT ALL TIMES

This is a 1928 Broad Street Hospital Out Patient Clinic identification card. It was used by John Taaffe when he was admitted for surgery.

NEW YORK, ————— March 21, 1928.

M—r. John Taafe.

TO BROAD STREET HOSPITAL

FOR BOARD OF Self	FROM 3/4/28	TO 24/28.	
21 DAYS @ 3.00		$ 63.00	
SPECIAL NURSES	DAY SERVICES @	$	
" "	NIGHT " @	$	
BOARD OF SPECIAL NURSES	" @	$	
OPERATING DEPARTMENT CHARGES		$ 10.00	
PATHOLOGICAL DEPARTMENT CHARGES		$	
X-RAY AND ELECTROTHERAPY DEPARTMENTS CHARGES		$ 10.00	
MISCELLANEOUS		$	
	PER	$ 83.00	

RECEIVED P BROAD STREET HOSPITAL

Broad Street Hospital, at 129 Broad Street, offered health services to Downtown residents. Jane Taaffe received this hospital bill in 1928 after her son John was treated for pneumonia. The cost for a hospital stay at that time was $3 a day. In 1945, the hospital merged with St. Gregory's Free Accident and Ambulance Station, on Gold Street, and became Beekman Downtown Hospital. The hospital was renamed New York University Downtown Hospital in 1997. It continues to operate on Beekman Street.

Six

THE LAST DAYS OF
THE NEIGHBORHOOD

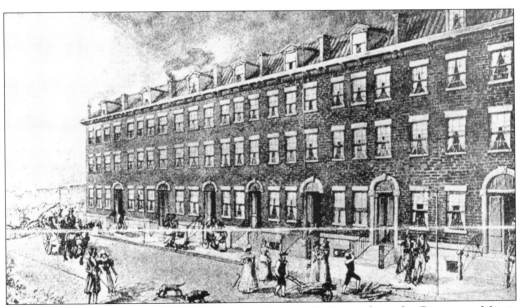

This 1825 print shows the buildings at 1–24 Greenwich Street, from the Battery to Morris Street. At that time, it was called Millionaires Row—a far cry from the tenements of 1915 through 1945. (Collection of the Museum of the City of New York.)

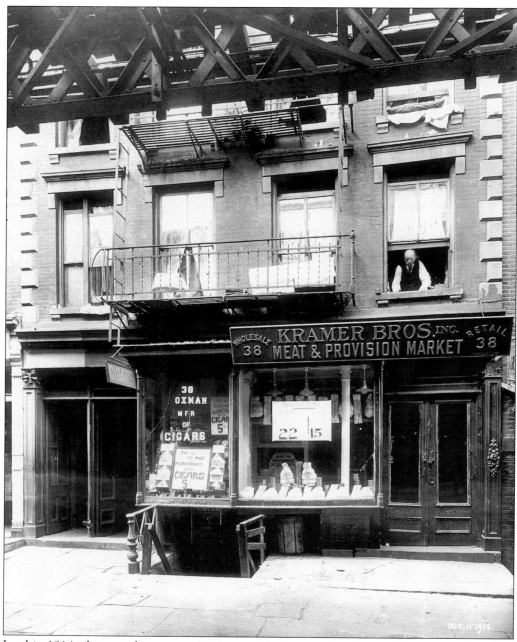

In this 1914 photograph, we see 38 Greenwich Street—the Kramer Brothers market and the Oxman cigar store. At the top of the picture is the Ninth Avenue El, the first elevated railway in New York City. The line was built in 1869–1870 and extended from Battery Place to 30th Street. It was constructed on a row of iron supports and consisted of a single track. The cars were operated to and from their destination by a cable. Locomotive power was added in 1871. (Collection of the Museum of the City of New York.)

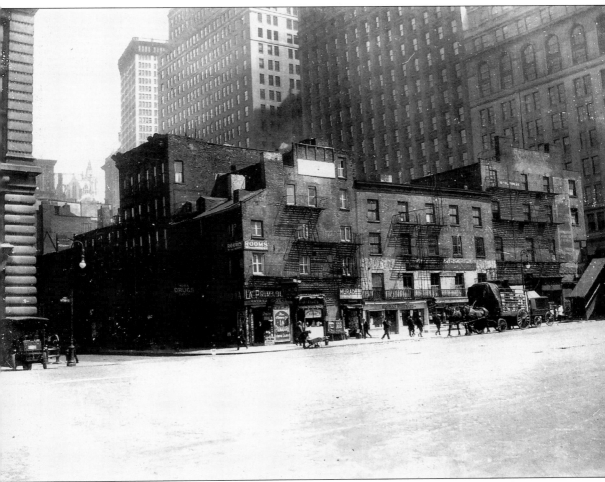

The towering buildings of the Financial District are seen in the background of this 1923 photograph of the neighborhood. The Whitehall Building, which is still standing, is to the left. The tenements begin at the corner of 1 Washington Street and Battery Place. To the far right is the Ninth Avenue El, which ran along Greenwich Street to South Ferry, the last stop. (Collection of the New-York Historical Society.)

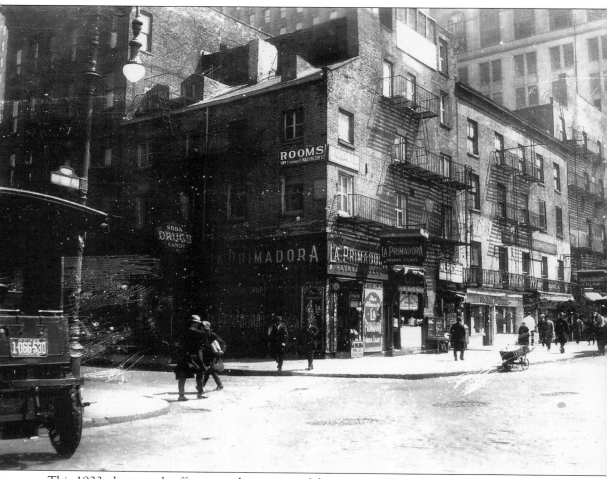

This 1923 photograph offers a northeast view of the corner of Washington Street and Battery Place. Newly arrived immigrants from eastern Europe, Syria, Greece, and Ireland settled in very quickly. The short ferry ride from Ellis Island landed the new arrivals at Battery Park, often with family and friends anxiously waiting. Soon they moved into their apartments and found jobs as porters, window washers, longshoremen, dishwashers, and cleaning women in the heart of the Financial District a few short blocks away. (Collection of the New-York Historical Society.)

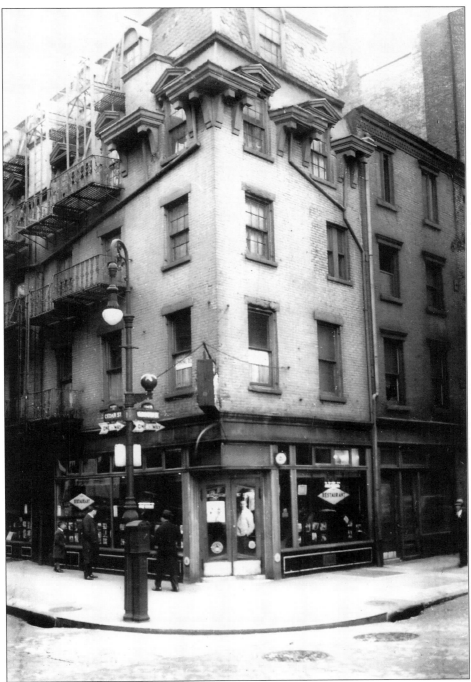

Here are Washington and Cedar Streets in 1937. One can understand why the residents did not want to leave this peaceful area. The apartment building looks well kept, and the storefronts and streets are clean. It is no wonder that the area residents fought with the city to stop the demolition of some of these lovely buildings for the Brooklyn Battery Tunnel. (Collection of the New-York Historical Society.)

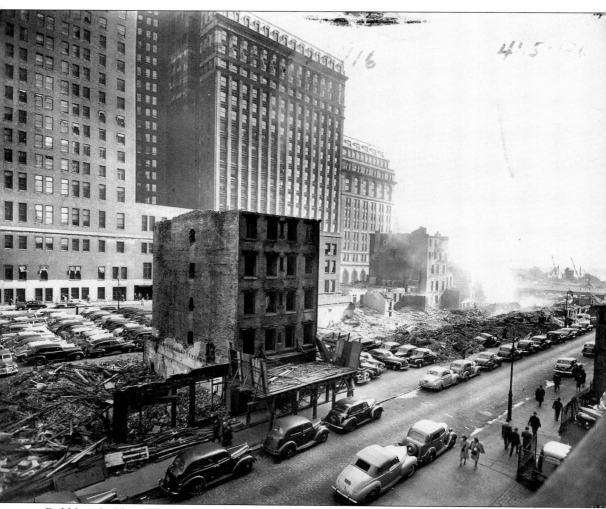

Rubble of old buildings surrounds the last of the Civil War–era tenements razed for the Brooklyn Battery Tunnel. Some of the displaced residents moved to Brooklyn, which made them "very unhappy," according to one old-timer, and some were able to move a little farther north toward Liberty and Cortland Streets. (Courtesy of John Taaffe.)

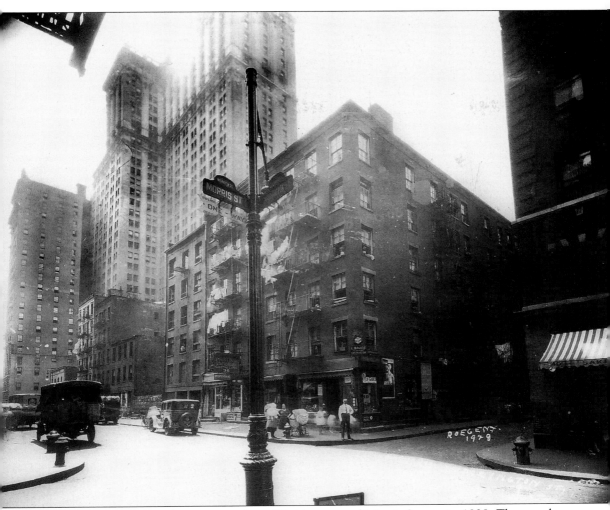

This is a typical row of tenements along Washington and Morris Streets in 1928. The people who lived in these buildings were friends and neighbors who considered their neighborhood a unique "island." This notion came about because they were surrounded by the Hudson River, Washington Market, high-rise office buildings, and Battery Park. (Collection of the New-York Historical Society.)

24 Hour Final Notice To Tenant

11/21/46 1946

Mr. *"Jane" Taffer* _____ tenant in possession of premises

No. _____ *15 Norris Street* _____ Brooklyn, N. Y.

You are hereby notified that Mr. *the City of New York*
the landlord of the above named premises has ordered me to obtain a Warrant
for your removal and posssession of the premises you now occupy, As the time
in which you are allowed to either pay the rent or vacate has expired. Under com-
mand of said Warrant it is my duty to remove tenant, and put the landlord in
possession. I shall therefore enforce said order by *Monday 25th November* 1946
at *11* o'clock in the *fore*noon, or any time thereafter, If you have not vacated.
If you are in dire distress immediately notify Home Relief Bureau upon receipt of
this notice.

Respectfully,

Arthur J. Upton

City Marshal No. *65.*

Here is an eviction notice dated November 12, 1946; the tenant fought to stay until the last
moment. But progress must go on, and the beginning of the last days of the neighborhood had
arrived. Work on the Brooklyn Battery Tunnel had begun. (Courtesy of John Taaffe.)

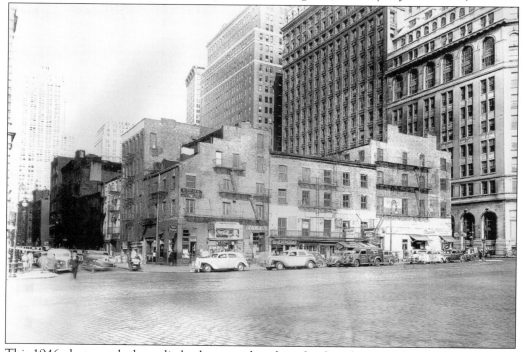

This 1946 photograph shows little change, other than the demolition of the Ninth Avenue El.
By the end of 1946, work began on the Brooklyn Battery Tunnel, and the tenements started to
be torn down. (Collection of the New-York Historical Society.)

Stickball was a favorite pastime for the young men in the neighborhood. On Sunday afternoons, the streets were empty of traffic and businesspeople. The game started in the early afternoon and lasted well into the early evening. In this 1939 photograph, a young man is playing on Albany Street. George's Candy Store (right) was a favorite gathering spot. Many of the meetings here of boys and girls ended with proposals and long-lasting marriages. To the left of the candy store are 9 and 11 Albany Street, the tenants of which usually gathered to watch the games. (Courtesy of Mary Fackovic.)

From left to right, Mary Gaydos, Anne Brkal, Olga Balas, and Katie Sikoryak pose in the Trinity Church graveyard in 1939. (Courtesy of Peter Balas.)

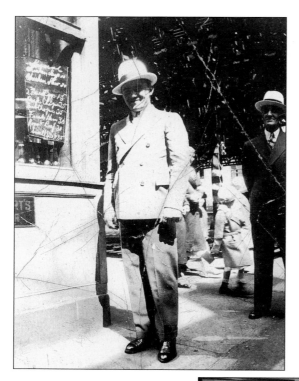

Thomas Taaffe Jr. is standing on the corner of Morris and Greenwich Streets in 1935. His father, Thomas Taaffe Sr., is standing in the background. Note the Ninth Avenue El above and the Greek restaurant at 42 Greenwich Street to the right of Thomas Sr. (Courtesy of John Taaffe.)

Helen Ceselka is pictured on the job. Ceselka lived on Albany Street and worked as a cleaning woman on Wall Street. The majority of cleaning women were immigrants of eastern European decent who lived Downtown. Some had two jobs in order to put their children through college. They would often gather in Battery Park before going to their second job. The ladies, enjoying their break, would small-talk and exchange favorite recipes. It was an advantage of living in Downtown; you walked to work. (Courtesy of Frank and Mary Zizik.)

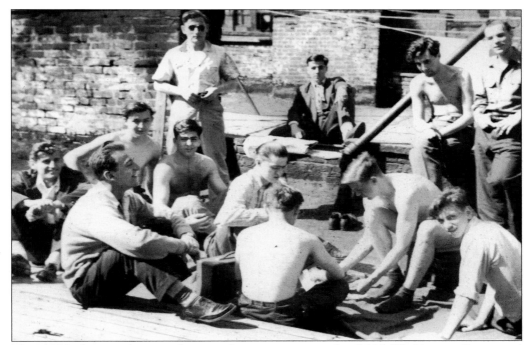

This 1946 photograph was taken on the connecting roofs of 135 Washington Street and 11 Albany Street. The tenement roofs were a favorite spot for taking pictures, relaxing, and playing cards. The boys featured in this photograph are playing a friendly game of cards. From left to right are the following: (first row) John Fornazor, Charlie "Mousie" Gaydos, and Nick Benyo; (second row) John Balas, Tommy Rizk, Mikey Cox, and George Sikoryak; (third row) John Gaydos, John "Buster" Hornak, "Big Dave" Srour, and Martin Baranski. (Courtesy of Peter Balas.)

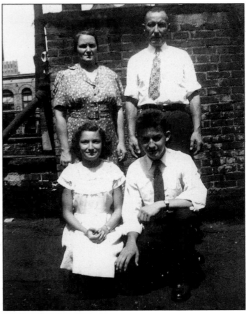

The Balas family is pictured on the roof of 135 Washington Street in 1945. From left to right are the following: (first row) Olga and John (Baba) Balas; (second row) Mary and Peter Balas. One son is not in the picture—Peter, who was serving in the armed forces at the time. Thankfully, he came home safely. (Courtesy of Peter Balas.)

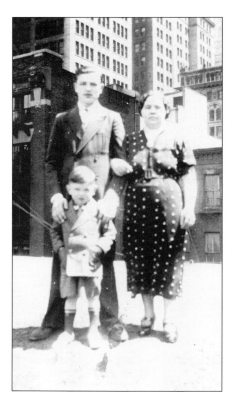

John Vislocky, Katherine Vislocky (mother), and younger brother Michael pose on the roof of 18 Trinity Place in 1938. John graduated from Hobart College and stayed at Hobart as an instructor in physics. Later, he received a master's degree in physics from Bucknell University. John served as a naval officer in World War II and retired as a lieutenant commander. He was manger of the IBM team in Huntsville, Alabama, at the NASA space center, where he worked under Dr. Wernher von Braun, the rocket scientist. John died in 1990. (Courtesy of Michael Vislocky.)

Shortly after arriving in America as a 16-year-old boy, Martin Rizek Sr. lived with his older brother, Paul, at 65 Greenwich Street. At the age of 23, Martin joined the U.S. Army Cavalry and was stationed at Waco, Texas. This photograph was taken in 1918. (Courtesy of Martin Rizek.)

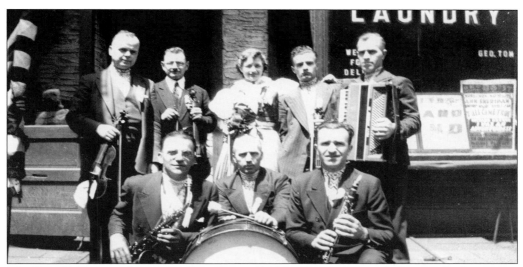

The Slovak American band played in almost all of the events that took place on the lower west side, including the 1940 Memorial Day celebration pictured here. (Courtesy of Martin Rizek.)

While on summer break from the Merchant Marine Academy, William Klus took a job as a lifeguard at Jefferson Baths, Coney Island, in the summer of 1937. One of his feats was swimming from the Battery to Liberty Island (the location of the Statue of Liberty) and back. Klus lived with his mother at 51 Washington Street. (Courtesy of Barbara Rizek.)

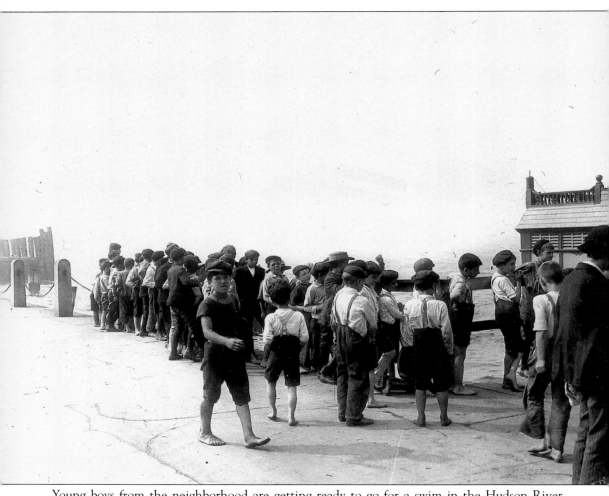

Young boys from the neighborhood are getting ready to go for a swim in the Hudson River at Battery Park in 1939. The Battery Park bathhouse was a favorite spot for boys to go on a hot summer day. Although neighborhood boys enjoyed swimming in the river, it was quite a dangerous activity because of the strong currents. Fortunately, there were no accidents. (Collection of the New-York Historical Society.)

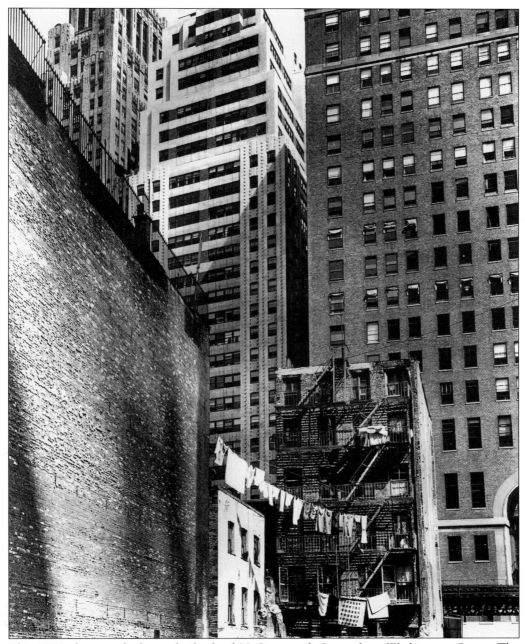

This 1938 photograph shows the back of 38 Greenwich Street from Washington Street. The laundry hanging on the lines of the tenements forms a striking contrast against the giant skyscrapers in the background. This is one of the many contrasts that made the neighborhood unique. (Collection of the Museum of the City of New York.)

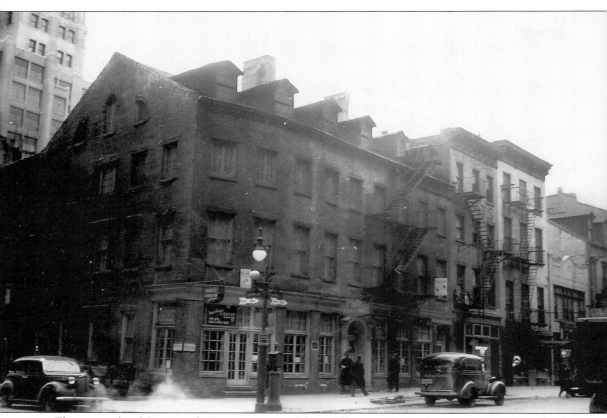

The west side of Greenwich Street is pictured from Albany to Cedar Streets in 1941. The third building from the corner was the home of well-known author Edgar Allen Poe. The building was built in 1809. (Collection of the New-York Historical Society.)

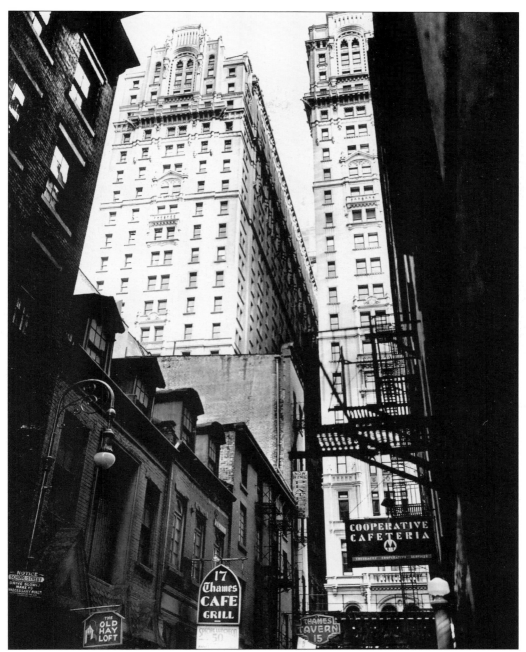

This view of Thames Street going east to Trinity Place shows how the tenements were nestled along this tiny street. On the left corner of Thames Street and Trinity Place stood St. Peter's School, built in 1800. On the right corner stood 90 Trinity Place, which housed the Downtown Chapter of the Slovak National School of New York, which originated in 1915. St. Peter's School was a Catholic grammar school. The Slovak school taught American-born children of Slovak immigrants about their culture and history and how to read and write the Slovak language. (Collection of the Museum of the City of New York.)

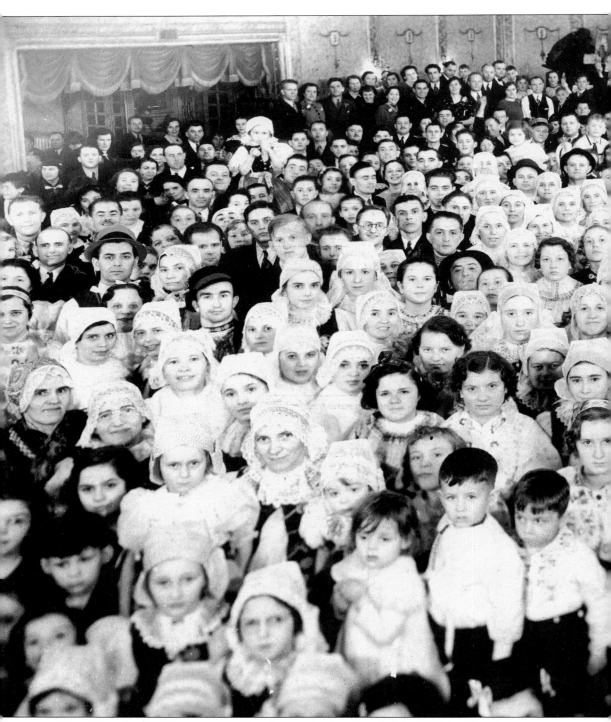

The Vrbovćiansky Kruzek was a Slovak organization founded in 1914 by Slovak immigrants at 14 Greenwich Street. The members paid dues and upon sickness, death, or troubled times, the organization helped families financially. The neighborhood dwindled, and the organization

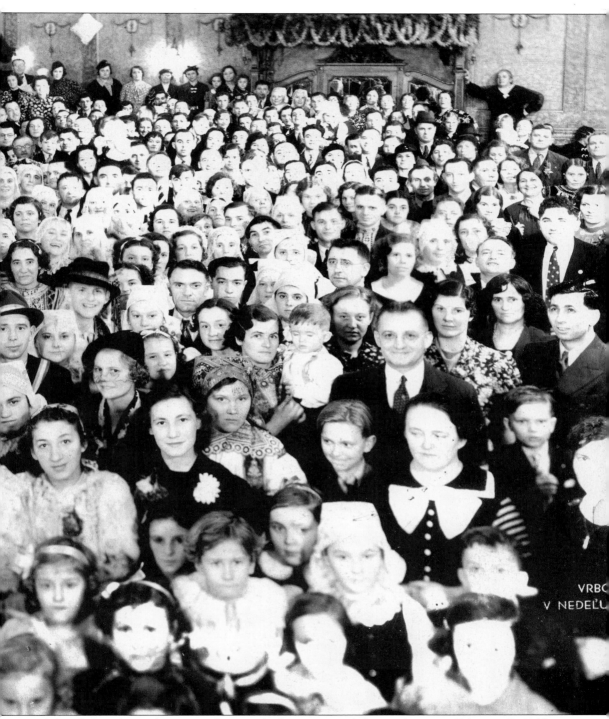

disbanded in the early 1990s. Photographed is an annual dinner dance on February 7, 1937. Most members are wearing their native costumes, which indicated their native towns. (Courtesy of Anna Praskać.)

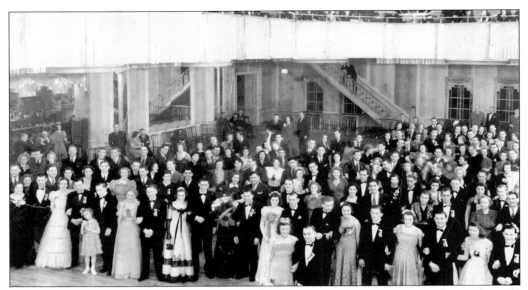

The Battery Pleasure Club, a Downtown social and sports organization, was made up of mostly Irish, Lebanese, Greeks, and Czechoslovakians. An entertainment dance was held annually at Webster Hall in Manhattan. The date of this photograph is March 3, 1939. With the building of the Brooklyn Battery Tunnel in the early 1940s, the Pleasure Club soon disbanded. (Courtesy of John Taafe.)

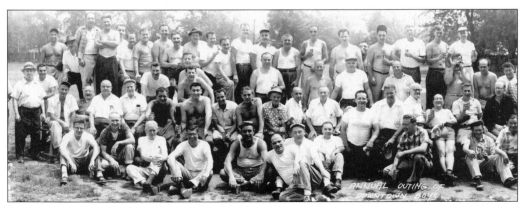

In place of the Battery Pleasure Club events, Downtown residents held an annual picnic and softball game, usually on Staten Island, until the late 1960s. Pictured is the gathering of July 18, 1959. (Courtesy of Stephen Podzamsky.)

This 1955 view of Greenwich and Rector Streets was taken looking north. Tenements are still standing. The apartment building on the left was torn down in 1957; a skyscraper now stands in its place. The building on the corner of Rector and Greenwich Streets, 14 Rector Street, had three families living in it until the late 1970s. The New York Landmarks Conservancy and the Greenwich Village Society for Historic Preservation are campaigning for this building to be designated a city landmark. This building has withstood almost 200 years of Downtown development, providing glimpses of lost streetscapes and bygone eras. (Collection of the Museum of the City of New York.)

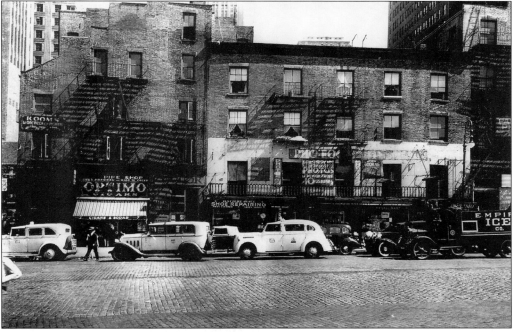

When this photograph of Battery Place was taken in 1937, many immigrants were arriving and expanding the neighborhood upward past Liberty Street. (Collection of the New-York Historical Society.)

This view of Greenwich Street looks south in 1958. The tall building on the right is 19 Rector Street, the former site of a tenement. The small building in front of 19 Rector Street is 14 Rector Street, which is 200 years old. (Courtesy of Joseph Chobor.)

The back of the American Stock Exchange can be seen on the right of this 1958 view of Greenwich Street, looking north. In the distance is Liberty Street, the future site of the World Trade Center. (Courtesy of Joseph Chobor.)

Seven

THE WORLD TRADE CENTER

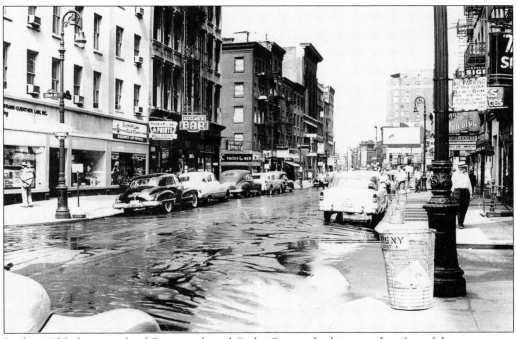

In this 1955 photograph of Greenwich and Cedar Streets, looking north, a few of the tenements are still standing. Slezak's, which opened as a grocery store in 1922 and moved several times, can be seen in the right-hand corner. The building above the shoe store on the corner was one of the last tenements. This is also where One World Trade Center once stood. (Collection of the Museum of the City of New York.)

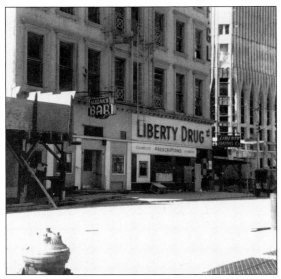

The construction of the World Trade Center is evident in this photograph. Liberty Drug and Slezak's were the last structures to be demolished. (Courtesy of Stephen Podzamsky.)

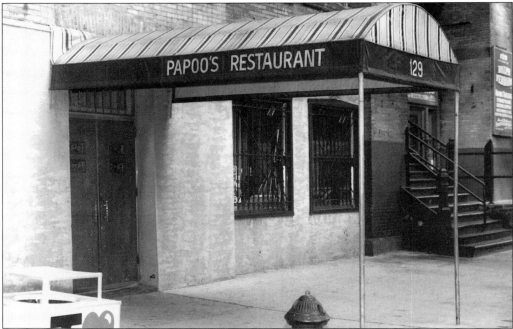

Harry Manolakas was born in 1914 on Albany Street and is the son of Nicholas Manolakas, a church officer who helped build St. Nicholas Greek Orthodox Church. Harry opened a coffee shop at 129 Greenwich Street in 1957. In 1968, Harry, his wife, Hilda, and his son Nick expanded the coffee shop to a successful restaurant and bar. On the occasion of their first grandchild, they named the restaurant Papoo's, after the Greek word *pappous*, meaning "grandfather." After Harry's demise in 1989, Nick and his mother, Hilda, operated the restaurant until September 11, 2001, when the restaurant was devastated. Nick reopened Papoo's at its present location, 55 Broadway, after 18 months of hard work and sacrifice. Hilda, unfortunately, did not get to see the new restaurant; she passed away in 2002. Nick and his sister Geri now operate the successful restaurant in his beloved lower west side neighborhood.

ACKNOWLEDGMENTS

We would like to give special thanks to John and Katherine Taaffe for their help in preparing this book; the pictures, stories, and articles were most valuable. We would also like to thank the following for the use of their personal pictures: Jim Maniatis, Mary Fackovec, Charles Gaydos, Frank and Mary Zizik, Peter Balas, Helen and John Fornazor, Marian Sahadi Ciaccia, Anna Jurovaty, Anna Petrak, Joseph Chobor, Michael Vislocky, Stephen Podzamsky, Anna Praskać, Joan O'Connor, Elizabeth Sukupcak, Anna Salony, John E. Petrick, Angela Kindya, Mary Medvecky, and Nicholas Manolakos. Thank you, Ed Shiner, for your story "A Brief History St. Joseph's Maronite Church in Manhattan the Forgotten Maronite Church of Ground Zero." Special thanks to Rudy Riska, who has been affiliated with the Downtown Athletic Club for over 40 years and is the executive director of the Heisman Memorial Trophy Trust. Rudy was born across the street from the Downtown Athletic Club on lower Greenwich Street. We thank him for inspiring us to go forward with this book. Special thanks to James A. Peterson, Ph.D, Fellow of the American College of Sports Medicine and founder of Coaches Choice, for connecting us with the publisher and for his time and effort. We would also like to thank Pastor Paul Baranek for his story of what life was like growing up in the Downtown neighborhood during the early 1930s and 1940s. Thanks also to the Parish of Trinity Church of the City of New York, the New-York Historical Society, and the Museum of the City of New York.

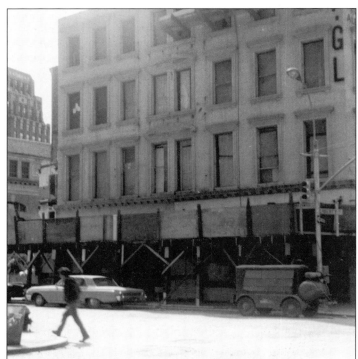

The construction of the World Trade Center is almost finished, and the quiet neighborhood the residents loved so dearly is gone. (Courtesy of Stephen Podzamsky.)

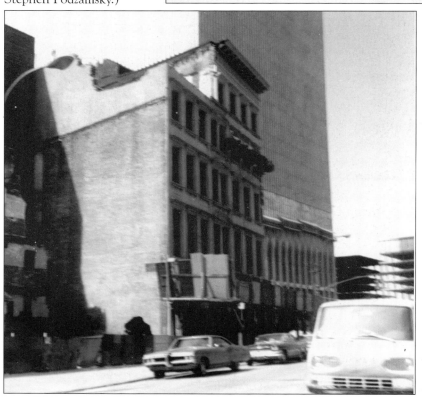